THE *A*RT OF THE HORSE

Reflections of the Past

JUSTIN B. EVANS

MAGAZINE COVERS AND ILLUSTRATIONS
PICTURE POSTCARDS
ADVERTISING ILLUSTRATIONS

WOOD RIVER PUBLISHING

TIBURON, CALIFORNIA

THE ART OF THE HORSE
Reflections of the Past

Wood River Publishing
680 Hawthorne Drive
Tiburon, CA 94920

First Edition May 1991

Design: Gabrielle Disario
Copy Editing: Lee Berman
Copy Photography: Martin Zeitman
Printing: Kin Keong, Singapore

Library of Congress Cataloging in Publication Data

ISBN: 0-9623000-9-8
CIP: 90-072054

TABLE OF CONTENTS

Cover illustration: U.S.A. Harrison Fisher. c.1910.

INTRODUCTION

*"The horse shall be for man a source of happiness and wealth;
its back shall be a seat of honor and its belly riches, and every grain
of barley given to it shall purchase the indulgence of a sinner and
be entered in the register of good works."*

Mohammed, c.650

*"God forbid that I should go to any heaven in which there
are no horses."*

R.B. Cunninghame-Graham,
20th century

*A*rtists, illustrators and photographers of
the past have left behind a wonderful visual legacy of graphic
material depicting mankind's evolving relationship with the
horse. What better way to appreciate the rise of horsemanship to
its eminent position in worldwide sport and leisure than by
looking at the vehicles that originally represented the world of
horses to the public: the magazine, the picture postcard, and
popular advertising.

Art representing horses has been influenced considerably
by changing modes in equestrian history. Therefore, we can see
the history of equestrianism strongly reflected in art. A view of
the art must certainly enhance one's knowledge of the history.

The era of modern riding as we know it began in England
in the mid-nineteenth century. Starting at this point in history
the art selections reproduced in this volume portray the infancy
and growth not only of modern riding but also of graphic
illustration throughout the world. The result is a visual record of
human ideas, social movements and significant historical
moments in the evolution of horsemanship as a sport. These
works vividly highlight social, cultural and commercial trends
from the time of mid-nineteenth century organized riding
events to the onset of World War II. An added delight is the
discovery that magazine covers, postcards and even advertise-
ments during this period were designed with extraordinary
imagination and beauty.

In most nations of the world, the nineteenth century public was characterized primarily by sports spectators, not participants. Horse racing garnered continual coverage in the papers, as did prizefighting and baseball in the United States, but most people just watched. One exception to the spectator rule was the rising popularity of cycling among men. Women in skirts could not expect comfortably to mount the high-wheeled bicycle.

In fact, up until the 1880s no leading popular activities had really emerged as vehicles for mass recreation. That all changed in the decade of the 1880s with a dramatic rise in interest in horsemanship and other participant sports in the United States and much of the world. At the same time, popular exposure of the sport in magazines, advertising and picture postcards finally showed the as yet unenlightened what a thrill it could be to ride on horseback for pleasure in the great outdoors.

In the early 1800s horsemanship and the art of graphic illustration were both highly specialized and not yet generally accessible to the public worldwide. As the cost of reproducing illustrations decreased, however, more and more magazine, postcard and advertising art relating to horses was offered to the growing middle class. Thus the popular growth of horsemanship paralleled its increasing popularity in the visual media.

New worlds were opened to people who discovered horses through printed images. Each visual resource played an important part in the public's perception of horses and increased interest and intrigue.

After the second World War, key technological advances in breeding, tack equipment and training began to appear. Coinciding with these developments, changes occurred in the representation of horses in the popular media. Increasingly, photojournalism began to replace the work of illustrators in magazines, advertising and picture postcards.

The graphic works in this compilation show the cultural, social and commercial roles of horses and riding from the mid-nineteenth to the mid-twentieth centuries, including changes in clothing, equipment, technique and public perceptions.

The pictures in this volume depict riding in an insightful, stylish and often evocative manner. Some of the graphics include touches of romance and sensuality. We encounter an idealized woman stroking her steed's mane, preparing for the thrill of the hunt, wearing a graceful dress and perfect hair under her fashionable riding cap.

Viewing these illustrations also shows us that the indomitable spirit that inspired early riders still characterizes the horse rider of today. The thrill and exhilaration experienced by people engaging in equestrian pursuits certainly have not changed, though styles of visual portrayal have evolved considerably.

Modern horsemanship is now well into its second century. The images collected in this volume present a significant part of the history of the horse itself and paint a vivid picture of popular riding's early years. Today, riding is no longer confined to wealthy gentlemen. Increasing numbers of riders now enjoy the thrill of horsemanship. And we all owe a great deal to the riders of the past who developed the ideas and methods generally practiced today.

Imagine, as you view the following illustrations, the excitement of the riders competing in new disciplines a century ago, training and riding new breeds for the first time. Sense the beauty of the horse's motion, the tranquility of the surroundings and the exhilaration of the experience as you enter a new

EQUESTRIAN HISTORY

*"On horses such as these even gods and heroes will appear,
and men who know how to work well with them look magnificent."*

Xenophon, c.400 B.C.

"A horse! A horse! My kingdom for a horse!"

William Shakespeare,
Richard III, 1592.

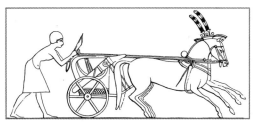

Ancient Egyptian chariot used for hunting and warfare.

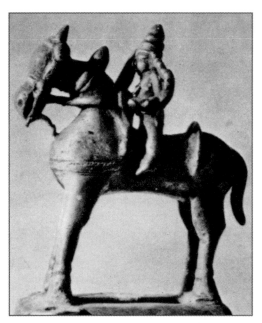

*Bronze horseman from southern Arabia, 2ⁿᵈ - 3ʳᵈ
millennium B.C.*

*M*uch of our human progress has depended upon our use of the horse. In addition, the horse has provided untold delight and pleasure to sport and recreation enthusiasts. The wonderful versatility of horseback riding is unsurpassed in the endless hours of productivity and enjoyment it brings to old and young alike.

There are over a hundred different breeds of horses today. Over time, a multitude of breeds have been developed from the various different key breeds used in sporting, competitive and recreational pursuits.

History of Riding

One of the earliest records of man riding a horse is an engraving on bone, found at Susa, an ancient capital in present-day Iran, around 3,000 B.C. Horses had been hunted as food from early times. They were domesticated when primitive agriculture first developed in the fertile valleys of Persia and Turkestan, probably to draw sleds and the first wheeled vehicles. As sources of food and water in the valleys and steppes were depleted, the strong, docile horse replaced oxen and other less agile beasts of burden. It also encouraged nomadic hunting. A mounted man could easily hunt fast-moving quarry and also raid dwellers in the fertile valleys. The first time man employed some means other than his own power to meet basic needs was an immense step in human history.

Many legends and myth surround horses. One well-known example is the centaur, half man and half horse, possibly derived from the appearance of mounted men to the incredulous who had previously seen neither horse nor rider. The psychological and physical advantages of horseback riders over people on foot greatly

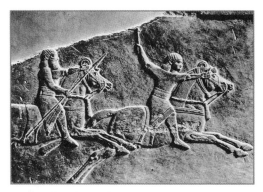

Assyrian huntsman. 9th century B.C.

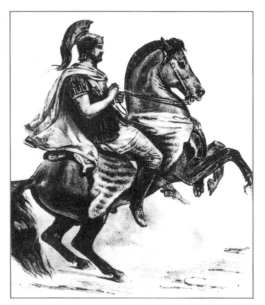

Xenophon, the founder of modern horsemanship.
400 B.C.

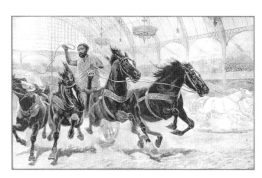

Chariot racing. c.300 A.D.

impressed our ancestors, and history and literature remind us that "to turn and wind a fiery Pegasus" is the height of superhuman power. Pegasus means, literally, "from the water." Mythological associations of the horse with the sea may derive from the practice of early invaders and colonists who transported horses by ship and sent them off the vessel to swim ashore.

Ancient sculpture also shows horses rising from the waves; Poseidon with his mighty horse-drawn chariot is just one famous instance. As for Pegasus, the depiction of a horse with wings may have been inspired by the speed of horses, which may well have suggested the speed of flight to the ancient Greeks.

For much of ancient history, our knowledge of horses comes from cave drawings, pottery and sculpture. From such depictions we know that Egyptian riders hunted lions, gazelle, ostriches, wild ox and even tigers. We can deduce that the Egyptian horses must have been well trained and obedient, as shown by their willingness to face their natural enemies.

Riding was at first considered suitable only for soldiers and archers, but it was soon deemed entirely fitting for a king or other ruler to be carried on a fine horse instead of sitting in a chariot. The earliest bits were of bone or ivory, crescent shaped, with holes drilled for attaching the reins. Later, advances in the working of metal enabled bits and other horse furnishings to be made of bronze, iron or silver.

Bits, bridles, buckles and bells have all been found in royal tombs. Ancient rulers' horses were sacrificed along with personal slaves, not only in the superstitious belief that they would continue to serve their masters, but because the horse was regarded as a comrade.

The first known book on equitation was written by Xenophon (430-354 B.C.), the son of a man of the equestrian class in Athens. Members of this elite corps submitted sons to years of training and to strict examinations. They had to be wealthy enough to provide two horses, an expense comparable to that of building a house.

During his years of service in the Peloponnesian wars, Xenophon learned many things from the Armenians and Persians, who had a longer tradition of horsemanship than the Athenians. His book, *On the Art of Horsemanship*, contains a great deal on what to look for when buying a horse, and much good advice on how to handle horses.

The horse must learn, Xenophon wrote, to associate man with everything he likes: food, rest and relief from flies. One of his maxims was that if a man buys, feeds, trains and exercises wisely, he

will own famous horses and be a famous horseman. The horse was bestowed on man for his happiness, he maintained, and the gift must not be abused. Xenophon was a true horseman, and the great masters still pay him tribute.

Charlemagne's kingdom in the ninth century stretched from the Pyrenees to part of Italy. Charlemagne imitated the oriental custom of parks or paradises — enclosures for hunting game. This led to the spread of royal and feudal parks in early Europe.

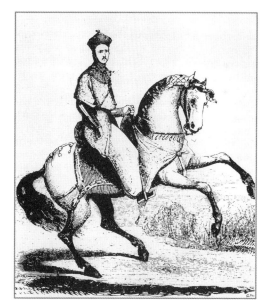

In the thirteenth century Genghis Khan established an empire from China to Poland based upon hordes of mobile guerrillas on tough, shaggy ponies. Messengers could travel over two hundred miles in twenty-four hours, with replacements at strategically planned staging points. Tremendous distances were covered by horsemen, both by cavalry and others engaged in warfare.

Genghis Khan, the Mongol conqueror who owed much to the horses in his cavalry. 13ᵗʰ c.

In medieval Europe, as swampland and forest gave way to tilled land, it became practical to breed and maintain larger horses, and these became the foundation stock of the Great Horse or *destrier*, able to carry a man in full armor. The Great Horse was expensive to train and feed. Because the knight would often have a sword in one hand and a shield in the other, the war horse had to learn to stop, move forward and turn in the midst of battle, responding entirely to signals from the rider's legs.

By the fifteenth century riding horses were specialized according to their purposes. Horses sired by famous studs, especially those with certain brand marks, fetched very high prices indeed.

Sixteenth-century troopers.

The invention of both the crossbow and firearms brought about a revolution in horsemanship in the sixteenth century. The horse now needed to be able to turn and maneuver, while the rider loaded, fired and reloaded his clumsy weapons. To outwit an assailant, riders needed to make sudden attacks to the rear, or to make quick retreats to avoid pistol shots from all sides. The horse therefore had to be controlled without giving away the rider's intention.

Early Riding in Europe

With the decline of the classical cultures in Europe, the art of horsemanship deteriorated. It was revived in Renaissance Italy, in the fourteenth-century, about two thousand years after its zenith. New discoveries in arts and science, philosophy and literature were complemented by a desire to recreate the classical forms of the Greek and Roman empires. It was this desire that stimulated the renewal of interest in horsemanship as an art form.

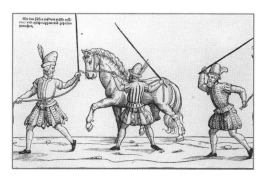

Woodcut from Grisone's Ordini di Cavalcare, *depicting remounts being brought from the stud into the riding stables.*

Like the fine arts, equitation flourished, and special riding academies were instituted. The Neapolitan school of horseman-

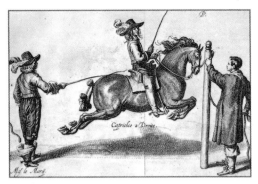

*The Duke of Newcastle (left) schooling horse and rider.
17ᵗʰ c.*

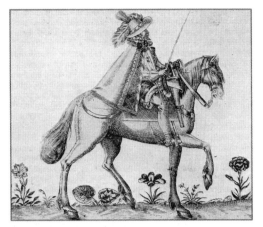

A sixteenth-century gentleman on his horse.

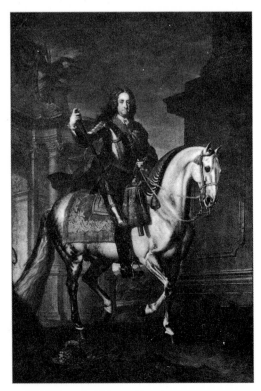

Charles VI in a knightly pose on a Lipizzaner stallion.

ship, set up by the Italian nobleman Federigo Grisone in the mid-sixteenth century, significantly developed and greatly expanded on the schools which had evolved in the Byzantine empire in the tenth century based on Xenophon's teachings of some twelve hundred years earlier.

Grisone, hailed by his contemporaries as "the Father of Equitation," excited particularly wide interest in Naples through his active practical teaching and the publication in 1552 of his *Ordini di Cavalcare*. Unlike most previous schools of training, Grisone's methods of mastering the horse did not preclude force.

Whereas Xenophon's objectives had been to produce a horse capable of active military service, the Neapolitan school and its imitators paid only lip service to the military aspects of training. Riding became an art in itself, and Naples soon became the center of a cult of formal riding that attracted young aristocrats from all over Europe.

The revival of horsemanship soon spread from the Neapolitan schools to France, where Antoine de Pluvinel, the Royal Equerry, practiced teaching methods he had learned in Italy, but in a noticeably refined form. By the seventeenth and eighteenth centuries the French, rather than the Italians, led the world in classical riding. One of the greatest riding masters of this period was Francois Robichon de la Guérinière (1688-1751), whose principles of training a horse to be calm, light and obedient still form the basis of today's dressage. Readiness, Pluvinel's ideal of being *bien dressé,* is the source for this key principal of training.

In exile in France and the Netherlands, the Englishman William Cavendish, Duke of Newcastle, devoted himself to his own method of training School horses. He is credited with inventing the caveson, or tie-down, and, by means of a special running rein, broke in his horses by forcing their necks to arch sharply on the spot and in small, tight circles. Cavendish shared his methods with his contemporaries and handed them down to posterity in a magnificent work, *New Methods of Breaking in Horses*, published in 1658.

The Spread of Riding

As northern Europe became industrialized, the teaching of riding grew more sophisticated. Germany, Poland and Russia all had great riding schools. In Vienna alone there were twenty.

The Spanish Riding School in Vienna was founded in 1580, as the home of classical horsemanship. Completed in 1735 for the Hapsburg emperor Charles VI, the Riding Hall, with its impressive architecture, saw the introduction of the magnificent Lipizzaner

stallions, descendants of Spanish and Neapolitan stock.

The triumph of the Lipizzaner in Austria was made unforgettable through the fluid, dancing movements of the aristocratic stallions, in the controlled display of their great strength, the magnificent leaps and the graceful quadrille ballet. The achievement of such graceful movements, especially the *airs above the ground*, required particularly talented horses.

Writing on the earliest forms of classical riding some 2500 years ago, Simon of Athens, a forerunner of Xenophon, wrote, "A dancer forced to dance by whip and spur would be no more beautiful than a horse similarly trained." With the Lipizzaner, the power and grace that stemmed from the animals' desire and ability to achieve owed little to whip or spur.

While the techniques of riding in enclosed spaces continued to fascinate the European horseman and indeed were introduced into military training at cavalry schools, Englishmen favored a much more dashing style of riding. This was partly fostered by the English passion for hunting, which, with the development of foxhunting during the eighteenth century, meant riding hard across country, and clearing obstacles in the way. Rivalry in the hunting field soon led to cross-country matches, with the first recorded steeplechase taking place in Ireland in 1752.

Racing over fences was followed by arena jumping, and again it was the Irish who led the way. In 1865 "leaping" contests were staged at the Royal Dublin Society's show, rapidly followed by similar events in other parts of the British Isles. In 1912, showjumping became an Olympic sport.

In the United States, two strong influences helped define characteristic American riding styles. The first, the Western seat, was a development based on Spanish techniques following the introduction of horses to the American continent by the conquistadors. Generally, however, along the Eastern seaboard, riders still continued to prefer the English hunting seat.

The second strong influence on modern American riding was Federico Caprilli (1868-1907), an Italian cavalry instructor. He advocated the forward seat and the shortening of the stirrups, which placed the rider's center of gravity forward to coincide with that of the horse, even when the two were in the air over an obstacle.

The advantages of Caprilli's ideas were soon universally recognized and, following the success of the Italian show jumping team before the first World War, the forward seat, with some modifications, was adopted all over the world.

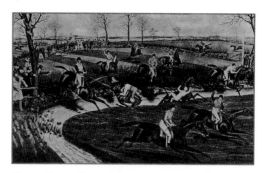
Liverpool Grand Steeplechase in 1839.

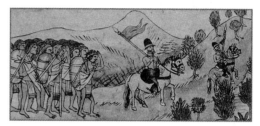
Early portrait of the Spanish conquistadors in America.

Horses in the United States

The concept of ranching, which first arose on the Asian steppes, developed further on the central plains of Spain in the fifteenth and sixteenth centuries. The Spanish took this concept with them when they brought their horses to the New World, providing new stock to replenish the American horse populations which had died out over the preceding 8,000 years.

In the New World the Spanish looked upon the horse as a creature of the heart, to be ridden or driven by gentlemen. For draft work, they preferred to use the ox, the mule and the donkey.

In the emerging colonies of New England, the Puritan values of many colonists caused them to reject the concept of the horseman as a superior being. Instead they saw the horse as an integral part of the work ethic. Colonists used the horse initially as a draft animal, as a partner in the opening up of land, rather than as a rich man's toy.

The return of the horse to the Americas also affected the lives of the indigenous Native American populations. The Plains Indians had formerly been nomadic hunters whose entire lives centered upon the search for food. As horses became available to them, through theft or barter, their way of life changed dramatically.

Adapting rapidly to this new resource, the North American Indians became superb horsemen, their skills matching those of the early Asian horseback archers. The original horse breeds brought by the Spanish rapidly evolved into vast herds of tough and wiry ponies, providing the Indians with ideal mounts. The Plains Indians (Apaches, Navahos, Pawnees and Comanches) soon became more than a match for the heavily armed Spanish horsemen. They could pour a hail of arrows from horseback far more swiftly than a Spanish trooper could reload his gun. Using these skills, the Indians were able to prevent the Spanish from spreading westward from Florida, a military factor which was of major importance to the future development of the United States.

Another contribution the Spaniards brought with them to the Americas was their style of riding. They rode with shortened leather and bent knees, the *short style*. This was the way horsemen from the East had always ridden. The American Indian rode in exactly the same manner. The rider leaned forward, with the horse outstretched. In Western Europe, in contrast, the knight had sat backward, with straight legs and stiff knees.

It took until the end of the nineteenth century, and Federico Caprilli's influence in Italy, before Europeans began to appreciate how important it was to ride short, with the weight going forward.

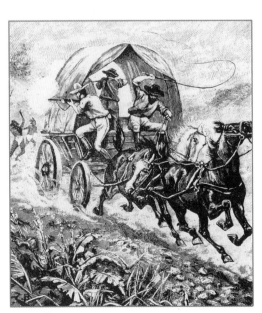

A Native American controlling his horse by means of a leather thong in its mouth.

A nineteenth-century covered wagon in the Far West, being attacked by Indians with firearms.

Up to this time there was an enormous division between the riders from the East who sat forward, the *light* horsemen, and the West's *heavy* horsemen, who sat back in a stiff manner.

The Great Breeds

Arabian

The most ancient of the modern breeds is the Arabian horse. We can trace its proud ancestry back at least three thousand years. While horses in other lands were still roaming about in wild herds, the Arabian was being tenderly reared by Bedouin nomads. In the many wars among the tribes, a sound, fleet and obedient mount could mean the difference between life and death, and a well-bred war mare was a prized possession.

The many centuries of controlled breeding and special attention the Arabian horse received undoubtedly helped it develop its undeniable intelligence. It is generally agreed that the Arabian has had the greatest influence on breeding and the world's horse population overall. It is one of the forebears of the English Thoroughbred, the Russian Orloff Trotter, the French Percheron, the American Morgan and many more.

The Arabian's unique stature can be attributed to three principal factors: first, its antiquity as a breed of fixed type and character; second, the development and improvement of the breed effected by the Bedouins over a period of centuries, (the Islamic religion incorporated the proper keeping of horses virtually as an article of faith); and finally, inherent qualities of stamina, hereditary soundness, conformation, courage and speed, which are so characteristic of the Arabian breed. Furthermore, Arabian horses' genes have the capacity to combine with those of virtually any other breed to effect an improvement on the resulting progeny.

It is not surprising that the Arabian horse, with such a history, in combination with its outstanding beauty, should have induced an almost fanatical devotion in its admirers. Add to all its exceptional qualities the romance of the East, and the Arabian horse becomes irresistible.

Thoroughbred

The creation of the Thoroughbred is undoubtedly the greatest achievement of the breeders of Arabian horses. In the late 1600s and early 1700s three Arabian stallions — the Byerly Turk, Darley Arabian and Godolphin Arabian — were imported to the British Isles. They were crossed with Barb or Royal mares imported by Charles II. Every Thoroughbred running today stems from one of these great Arabian sires.

The Arab Tent. *Sir Edwin Landseer. 1865.*

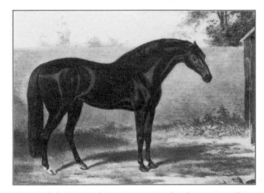

The Godolphin Arabian, sent to England in 1729. This was the youngest of the three stallions from which all thoroughbreds descend.

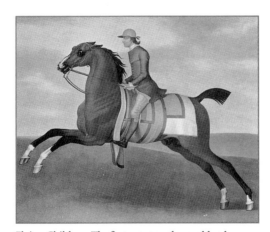

Flying Childers. *The first supreme thoroughbred racehorse, bred in 1715. He won every race he started. In his own time and for long afterwards he was considered not only the best horse ever seen, but the best ever likely to be seen, an unrepeatable phenomenon.*

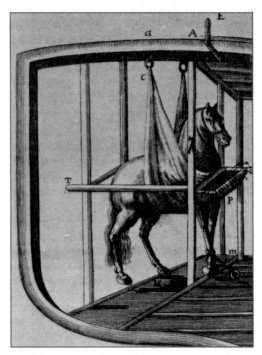

How the Conquistadors took their horses to America.

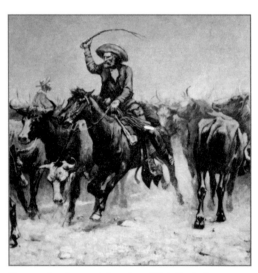

Conquering the great American West. Frederic Remington.

Due to its desert background and years of inbreeding, the Thoroughbred is not only the fastest and most beautiful of horses, but also the most spirited, sensitive, and excitable. Along with the Arabian, its temperament is considered to be "hot-blooded," or spirited, as opposed to other more docile strains. The Thoroughbred is the champion athlete among modern horses, as it has been bred especially for speed and jumping ability.

The word Thoroughbred, as applied to the racehorse, was not used until 1821 when it appeared in Weatherby's General Stud Book. It was not until later that the Thoroughbred was established as a breed in its own right. Indeed, it is only in the last hundred years that the Thoroughbred has achieved its remarkable increase in numbers and has been transported to all parts of the world.

The Thoroughbred is the ideal riding horse, displaying the essential quality of speed, as well as a long, free and easy motion at all paces. Since action is dependent upon conformation, that of the Thoroughbred is the nearest to perfection. Add to this the qualities of balance and true symmetry of proportions, and the Thoroughbred is without a doubt the aristocrat of the equine species.

Native Bred Horses Around the World

In addition to the Arabian and the Thoroughbred, many famous native breeds from around the world have evolved. Over a hundred recognized breeds of horses and an infinite number of crossbreeds have developed since the prehistoric five-toed Phenacodus and the four-toed Eohippus evolved into the handsome one-toed animal we call a horse.

The United States and Canada

In the sixteenth century Cortes and his conquistadors rode into old Mexico bringing Spanish domination with them, destroying old cultures and imposing their rule and religion on the New World of the Americas. Without the horse, the conquistadors' ravages into the interior would have been virtually impossible, a fact fully realized by Cortes when preparing for his expedition. Sixteen horses, eleven stallions and five mares, left Spain for the New World. It is from the survivors of this band, and the many that followed, that the vast herds of America grew, and from the subsequent importations of bloodstock from England, Europe and the East, that the breeds of America took shape.

The Quarter Horse has a long history dating back to Colonial days in America, when horses descended from old Spanish stock were crossed with blood imports from England. In its early years, the Quarter Horse was centered mainly in Virginia and the Caro-

linas, and it was here the breed name originated. Freed from the weekday work, farmers and plantation owners indulged in their favorite Sunday pastime — match racing their finest horses down the Southern towns' main streets. It was a rare town that could boast a street longer than a quarter mile, and from this the stocky, fast starting little horses took their name.

The colorful American Paint Horse is closely related to the Quarter Horse and became very popular in America due to its versatility. Predominantly a Western horse, it figures prominently in open shows where it provides audiences with an eyeful of color. The Paint is also entered in many competitive events open to Western horses — pleasure, reining, roping, cutting, speed events and trail — as well as the English divisions in jumping and pleasure.

The Standardbred was derived from a British Thoroughbred imported into the United States in 1788. In those days, particularly in the eastern states, harness racing was popular at country fairs. Winners were determined by holding several heats, the horse winning the most heats being the overall winner. This tough method resulted in the elimination of weaker animals and encouraged the use of the better horses for breeding stock.

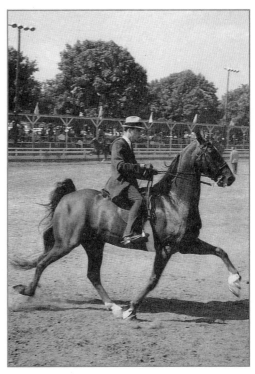

A five-gaited standardbred, ridden in saddle seat style.

The Morgan horse, the oldest of the American breeds, takes its name from a Vermont man by the name of Justin Morgan who acquired the first stud of this distinctive breed as a two year old in about 1793. The colt was an offspring of a Thoroughbred. This first colt's success in match-racing, pulling contests and as a trotter in harness put him in steady demand as a sire.

Sons and daughters, all virtually mirror images of the first Morgan, began dotting the countryside. Demand for them grew as people noticed their good looks and performance. Today, Morgans are known as show horses for both driving and English riding, but because of their stamina, they have become popular among Western riders as well. They are one of today's handsomest breeds.

Hailing from Kentucky, the Saddlebred was developed by settlers in the early days of American independence. By crossing Thoroughbreds, Morgans and Standardbreds, they produced the first of this elegant breed. The Saddlebred became a natural for the show ring and is primarily a show and pleasure horse.

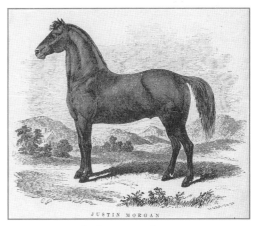

Justin Morgan, *the first Morgan horse. 1793.*

The Tennessee Walking Horse originated two hundred years ago as an all-around work horse that proved to be equally at home in harness, under saddle, or on the farm. Because of its remarkably smooth gaits, the Walker was in demand on the vast cotton and tobacco plantations of the southern states, where landowners and their overseers needed a horse capable of giving a supremely com-

fortable ride. Today, a small portion of the Walking Horse population is trained for show. The vast majority are used for pleasure and trail riding, offering a comfortable ride devoid of any jarring.

Great Britain

Great Britain has a unique heritage in her famous native breeds, which include the ponies Exmoor, Dartmoor, New Forest, Fell, Dales, Highland, Shetland, Cleveland Bay and Welsh breeds. Heavy horses include the Clydesdale, Shire and Suffolk Punch.

The British have developed many different types of horses from their native breeds. The hunter comes in all shapes, sizes and colors, because it is not a specific breed. The name is applied to any horse used for the purpose of hunting. The English practice of encouraging the breeding of hunters began in 1885 with the founding of the National Light Horse Breeding Society.

There are two varieties of English hack — the park hack and the covert hack. The park hack traditionally is the type of horse on which ladies and gentlemen of leisure go riding, either on their private estates or in the public parks in town. The emphasis is on elegance, movement, manners and comfort. The covert hack serves a slightly different purpose. It is the animal a man rides to the hunt before mounting his hunter.

The Cob is the mount of heavy, elderly riders who want a comfortable ride without any fireworks and who appreciate the horse's lack of height when mounting and dismounting. The Cob is as much used in harness as under saddle, and is ideally suited for this dual role.

The Hackney originated during the early eighteenth century in Britain and was known as a trotting horse. By the nineteenth century the Hackney had become firmly established as a riding horse and pack horse, and was the means of transport used by many farmers. As the railway system reduced the demand for the Hackney as a riding horse, its popularity as a harness horse increased. By the turn of the twentieth century the Hackney had firmly established itself in Britain and abroad as the finest harness horse in the world, and has since maintained its worldwide popularity.

France

Thoroughbred breeding centers in Normandy and the Bearn possess records of racing as far back as the sixth century. The first regular races took place in the early eighteenth century, during the reign of Louis XIV, and began with private bets and a series of dares.

Toward the end of the eighteenth century, Thoroughbreds were imported from England, and in 1780 a set of racing rules was drawn up. The French Revolution of 1789 proved to be only a

Champion cob, Cromwell, *who was Irish bred.*

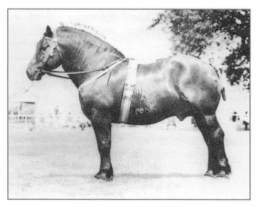

Percheron stallion, originally developed by a group of farmers in the La Perche district of France.

temporary setback to racing, and after 1805 the studs and racing were reestablished and the French stud book created.

In 1833 the Societe d'Encouragement, which still rules French racing, was founded. Two years later the Societe created the Prix du Jockey Club — the French Derby. In 1865 Gladiateur's victories in England proved that the French Thoroughbred could compete successfully against its English counterpart. The breed is officially known as the Pur-sang Anglais — an English Thoroughbred bred in France. The principal horses of the part-bred families include the Demi-sang or Anglo-Norman, the Vendee, Charente, Loire-Atlantique and Deux Sevres; the Charolais; the Limousin; the Camarguais; and the French Trotter. Among the many draft horses in France, the four principal breeds are the Boulonnais, the Percheron, the Ardennais and the Breton.

Germany

In Germany today there are three principal horse breeds, the Holstein, Hanoverian and East Prussian. Local provincial strains have been created by using stallions of these breeds plus the Thoroughbred. The first stud orders for the Holstein were issued in 1680, and the famous white horses were first bred in the Royal Stud at Esserom. They were introduced to Britain by George I, where they were used in the royal mews and at Windsor.

The Hanoverian has become increasingly popular as a competition horse, particularly in dressage and show-jumping. The rare East Prussian or Trakehner horse is selectively raised in relatively small numbers. Other German breeds include the Dülmen, the Haflinger, the Noriker, the Schleswig and Jutland.

Italy

The Etruscans of 2500 years ago were probably the first people to produce a useful type of horse for riding and driving. During the seventeenth century Arabians, Barbs and the Old Spanish horse breeds contributed to the evolution of the Neapolitan horse, which was bred around Naples and Sorrento. Thoroughbred horses have long played an important role in Italy. Equally, the American Standardbred trotter is enormously popular.

Switzerland

One of the earliest known engravings of a wild horse was discovered at Shaffhausen in Switzerland, and is dated to the Early Stone Age, 1,000,000 to 50,000 B.C. The horse has continued to be of great importance in Switzerland since that early time.

With the beginnings of knightly chivalry in the tenth century, certain cloisters and abbeys were founded by the emperors of the Holy Roman Empire, which included modern Switzerland. One of

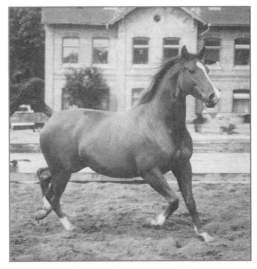

An example of the rare Trakehner breed, from Germany.

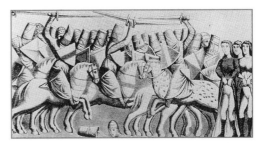

Depiction of Swiss knights of the Roman empire.

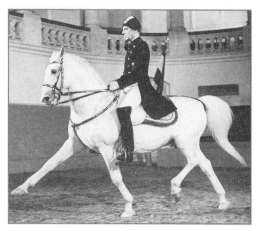

A famous Lipizzaner from Vienna.

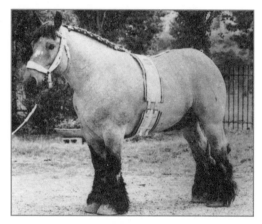

An Andalusian horse from Spain.

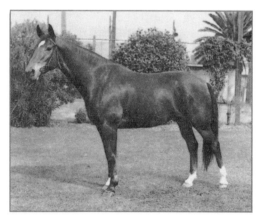

The Australian Waler, a breed that has contributed enormously to the development of Australia and to the work of its armies.

the oldest studs in Europe has been traced to one of these Swiss abbeys in the year 1064.

Federal studs were established about a hundred years ago to breed horses for defense purposes. In 1865 the first exhibition of Swiss horses was held in Aarau at which time the three principal breeds, the Freiberger, Erlenbacher and Schwyzer, were shown.

Austria and Hungary

From the earliest historical times the vast *puszta* country that is now known as Hungary was the habitat of wild equine populations. Later, in its equestrian prime, the country was part of the great Austro-Hungarian Empire with close connections through the Court with Spain, which supplied stallions to most of the royal studs of Europe.

The native horse of Hungary was small, very fast and had plenty of stamina, and it formed the basis for several very hard warm-blood breeds. State studs were established in 1774 to breed remounts and cavalry horses. Other studs were added later to breed for agricultural purposes. The well known Lipizzaner is the most famous Austrian breed.

Spain

The great contribution of the Iberian Peninsula to the world's horses has been the famous Andalusian. For many centuries this horse from southern Spain was the most sought-after mount in Europe; at one time exportation of breeding stock from Spain was forbidden, on pain of death and confiscation of property.

During the great years of Spain's golden age in the fifteenth century, the Andalusian made history in both Europe and in the Americas. In Austria in the sixteenth century this breed laid the foundation for the Lipizzaner of the Spanish Riding School of Vienna. The breed provided the mounts of the conquistadors in Spain's conquest of the Americas. Andalusian blood lives on in the Americas in the Quarter Horse, the Appaloosa, the Saddle Horse, the Palomino, the Pinto and the Mustang in the United States and Mexico, the Peruvian Paso in Peru, the Criollo in Argentina, the Colombian Paso in Colombia, and the Paso Fino in Puerto Rico.

Australia and New Zealand

The most famous Australian horse is the Waler, reaching the peak of its worldwide fame during the nineteenth century. In the days of the British presence in India, the Australian Waler was in great demand as a remount and artillery horse. During the first world war more than 120,000 of these iron-hard horses were sent to the Allied armies in Europe, the Middle East, India and Africa.

Today's decendants of the Waler have been designated as the Australian Stockhorse, which is very popular for working cattle on the huge stations of the outback. This horse has also proven very adept in endurance riding competitions, where its stamina, toughness and persistence have all stood it in good stead.

Another horse of the Australian bush is the Brumby, a wild horse living in free-ranging bands. Where racing is a major passion, the breeding of Thoroughbreds has become an increasingly important activity in Australia.

New Zealand has many of the same breeds found in Australia. New Zealanders specialize in breeding trotters and pacers. Horsemen there are very interested in hunting, and as a result breed excellent hunting horses.

China

The Asiatic Wild Horse is the ancestor of all Chinese breeds. The horse was native and wild, and was hunted and eaten by Stone Age man before 2,000 B.C. There are districts in China where horse breeding has been practiced since ancient times, particularly that of the Hsia (c.2000 B.C.) where the invention of the horse-drawn chariot is believed to have taken place.

In the valley of the Hwang Ho, during the Shang dynasty in 1639 B.C., institutions began to develop on the strength of the horse-drawn war chariots. Ever since that time, the Chinese have been a great equestrian people.

Tack and Riding Fashion

As the tools are, so is the work. The evolution in the attitude of man toward the horse at various stages in the development of horsemanship is reflected in the rider's appliances, in the simple or ingenious, brutal or elegant fashioning of equipment, as well as the practical nature of the rider's dress.

The Bridle

The American Plains Indian is known to have tied a strip of rawhide around the lower jaw of a horse, a practice that was actually predated by the more sophisticated hand-forged bits found in the Bronze Age. The Greeks and Romans are known to have used both the snaffle bit and the curb bit.

At the beginning of the eighteenth century the bridle was buckled over the top of the horse's head, instead of being placed as it is today on either side of the head. It was very simple, comprising a simple cheek snaffle and no noseband. By the middle of the century the horse was still normally ridden using the cheek snaffle,

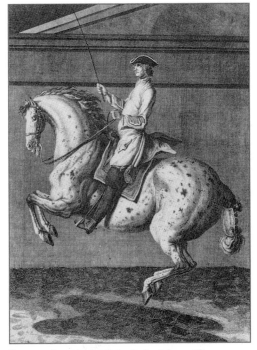

Sequence from Grosse Reitschule. *Johann Elias Ridinger. 1742.*

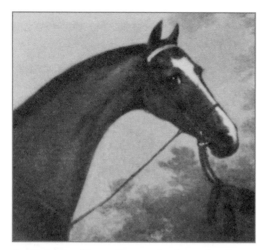

Snaffle bridle with standing martingale, noseband, colored browband and pulled mane. c.1790.

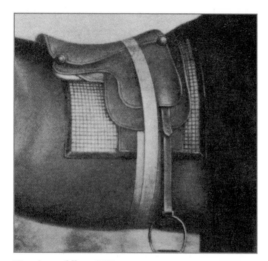

Hunting saddle. c.1750.

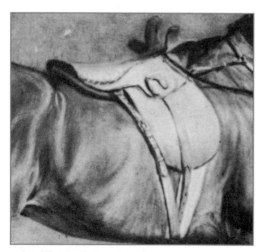

Sidesaddle, three pommels. c.1830.

although it was becoming more fashionable to use a form of pelham, or single mouthpiece, with two reins and a curb chain. It was not until the mid-twentieth century that the snaffle lost its cheek pieces; it is now a simple and slightly larger ring.

In horse racing of the early nineteenth century, two reins were attached to the snaffle, presumably for safety in case one of the reins broke. It was fashionable to ride steeplechases in double bridles.

The running martingale was developed at the end of the eighteenth century in England for more control of the horse. The running martingale, which remains in use today, is a leather strap fitted to the girth between the horse's front legs and which comes up under the breast, guided for safety between the leather of a neck strap, where it divides into two. On the end of each of the two pieces is a metal ring, through which run the reins. The purpose of the martingale is to restrict the horse if it tries to lift his head too high to avoid control by the bit.

The Saddle

The first riders did not have the advantage of the saddle, and control of their mounts was often haphazard. The Romans are credited with producing the first saddle, a high-peaked affair that most likely developed from the addition of rolls of padding to the basic saddlecloth. Later, medieval and Oriental saddles were developed with high backs to support the warrior as he charged with his lance. These chair-like saddles did not last long, however, for when the warrior was on the receiving end of the lance, he often discovered the high back supported him so well his spine would break before the saddle did.

The ladies' sidesaddle dates from approximately the twelfth century, and the Spanish saddles ridden by the Conquistadors, obvious ancestors of the American Western saddle, date from about the same time.

During the first half of the eighteenth century the racing saddle was very similar to the hunting saddle. In the 1740s some distinct changes began to appear. A large square saddle cloth was used, over which a saddle with three flaps was placed. Over the saddle a safety girth was fitted, as it is today for both racing and eventing. By the end of the century saddles were greatly simplified, becoming similar to those used today.

In 1830 a French riding instructor invented the third pommel, or *leaping head*, for the lady's sidesaddle. This pommel was to the left side of the saddle and curved slightly downwards. The left thigh fitted under the pommel to enable the lady to brace herself against the saddle, giving a far stronger seat.

It was rare to see a lady in hunting pictures prior to the invention of the leaping head. Up to that time it took a very capable lady indeed to ride sidesaddle across rough terrain, and few tried. Even after the introduction of the leaping head, a lady's horse was trained never to trot, only to walk and canter, as the trot is a most uncomfortable gait when riding sidesaddle. The sidesaddle remained popular until the 1920s, when adventurous women of the time found they could certainly ride forward as easily as the men!

The hunting seat of the nineteenth century was fairly upright, and, in the *flying leap*, the objective was to lean back, because it was considered highly dangerous to lean forward. In 1897 an American, Tod Sloane, brought the forward seat to Europe. Most riders shunned it, but Sloane proved so successful on the racetrack that one or two jockeys tried it with great success, and it was adopted universally in the 1900s. The Italians were quick to adopt the forward seat for show jumping.

The basic principle of the forward seat is that, by riding with a shorter stirrup and leaning forward at the gallop and over fences, one is able to balance one's weight over the fulcrum of the horse. The rider remains in complete balance with the horse instead of behind the movement, with the result that the rider does not hinder the natural balance of the animal.

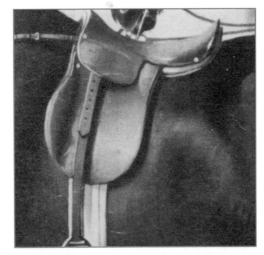

Hunting saddle. c.1870.

Evolution of Riding Apparel

Apparel for the horse rider evolved over centuries, and designs were developed to fulfill specific needs and functions. Because of the practicality of the styles and fashions that reached their peak of development in nineteenth century England and America, there have been few changes or concessions to popular fashion trends since that time. Levi's, Stetsons, hunting *pinks*, and top boots still look much as they did around the turn of the century.

The English riding outfit of the eighteenth century country gentleman set the style for all men's clothing (and some ladies' garb as well) worn throughout the Western world today. When William Coke, Duke of Norfolk, went to court to plead the cause of the American colonies to George III, he wore the fashionable riding clothes typical of aristocratic English gentlemen of the day. By doing so he soon launched a revolution of his own. Gainsborough immortalized the costume in paint, and within a generation, everyone in England was wearing similar styles.

Hunting and riding for sport had developed late in the eighteenth century, and the French styles then ruling the world were unsuitable. Riders needed simple materials that could be easily cleaned and were sturdy enough to withstand the wear and tear of

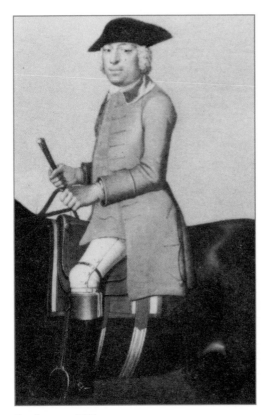

Gentleman. c.1750.

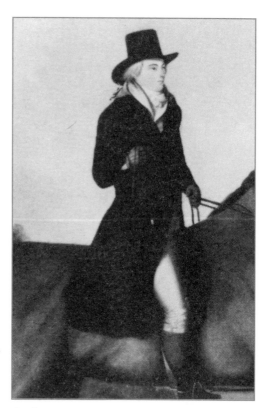

Gentleman. c.1790.

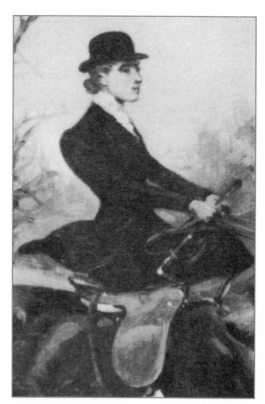

Lady hunting (a married lady would wear a top hat).
c.1910.

the hunting field. Coats became shorter and cut away at the front for freedom and comfort. Breeches replaced silk hose, plain linen rather than lace ruffles graced the neck, and high-crowned hats were devised to save the rider's head in case of a fall.

At the end of the seventeenth century a typical hunter wore a tricorn hat. The boots of the period were made to rise above the knee, but since this hindered the movement of the leg when riding, the top was turned down. This variation created the *top boot* still traditionally worn by hunt servants and gentlemen of today.

By the mid-eighteenth century a gentleman's clothing was far less ornate than previously, but he still wore the tricorn hat, while the hunt servants and jockeys wore a velvet cap. The breeches buttoned halfway up the thigh, a strap fastened above the knee; the boot became a top boot, much like today's, with a white leather strap and a tag which hung down toward the back of the boot.

Fashions in dress were making quite marked changes by the 1780s. The tricorned hat seems to have given way to a broad brimmed hat, variations of which were seen throughout the next twenty years, as it gradually transformed into a top hat. Boots also changed to a style with the top folded down, reaching slightly more than halfway down the leg. The man's coat became simpler and appeared to be better suited to riding.

Ladies were not so easily accommodated. In the early eighteenth century, riding clothes for women resembled masculine garb, but by mid-century, Englishwomen rarely rode astride. Few of them hunted until well into the nineteenth century, if only because the sidesaddle was uncomfortable and dangerous for cross-country riding. When the third pommel was invented, it became safer for ladies to hunt, but the clothing, at least from the waist down, had to be specially designed for the saddle.

Hunting clothes for the first thirty years of the nineteenth century were highly impractical: the gentleman's jacket was quite cut away, hence the name *cutaway*. This style gave little protection from the elements, although the hunt jacket was full-skirted, to protect the thighs. The top hat was quite elegant.

Dress in the 1840s was influenced by the dashing steeplechasers who wore a thin leather racing boot, pushed halfway down the leg, falling into wrinkles around the ankle. Breeches were of leather or, in the provinces, cotton and cut a little looser than in the past.

These changes in the mid-nineteenth century led to the demise of the cutaway jacket, to the fashion of a more sensible, substantial skirted hunt coat. The top hat was now quite tall, with

a wider top, and was for the first time laced to the gentleman's coat, to avoid losing the hat during a run.

Sport

Flat Racing

Horse racing has been a popular sport for thousands of years. There are accounts of it in ancient Egypt and Greece, and no self-respecting Roman circus would have been without mounted horse races in addition to the more spectacular chariot races.

The first record of a race in England took place at Smithfield in about 1174 during the reign of Henry II. Until the time of Charles II in the seventeenth century, horses used for racing in Britain were homebred horses known as the *hobby horse* or *running horse*.

It was not until the beginning of the eighteenth century that a revolutionary change came to horse racing and breeding. The importation of three Arabian horses from the East led to the origin of the magnificent new breed, the Thoroughbred.

In the modern era, the English Thoroughbred horse surpasses all others as a quality racehorse. The suitability of a climate for breeding Thoroughbred horses has determined the most popular locations of the sport.

The British royal family has always taken a keen interest in racing. Charles II was himself a principal arbiter when any disputes arose, and the aristocratic status of this *sport of kings* has always been maintained. Queen Anne was responsible for the Ascot racecourse, which was laid out in 1711 and has remained the most fashionable of all the British courses.

In the eighteenth century, there were hard-riding amateur jockeys, many of them peers, who rode against each other on horses they had bred themselves. In the early days of racing the most common distance was four miles (6.4 km), resulting in exhausted horses. This problem led to gradual reductions in racing distances.

Racing was first introduced to the United States in 1664 by the commander of the English forces invading what is now New York. The Commander laid out a 3.2 km (2 mile) course close to the present-day Belmont Park course, still internationally the best known of the North American courses.

Steeplechasing

In their earliest form steeplechases were private hunting matches, with large wagers staked between participants. In 1752, in Ireland, one of the most famous matches was conducted from Buttevant Church to the point at which the spire of St. Leger church

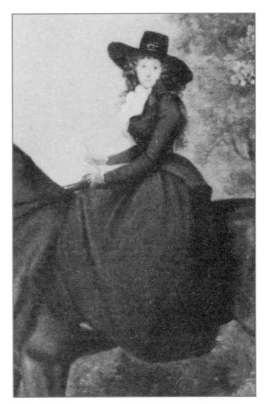

Lady. c.1790.

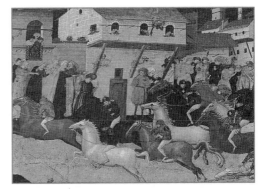

Racing in Florence, Italy in 1400. The riders carried clubs, which in rougher races were used on opponents.

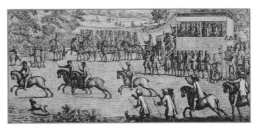

Windsor races in 1684, with Charles II watching.

could be seen peeping above the trees. Hence the adoption of the name *steeplechase*.

A variation at that time saw hunting men amusing themselves with what are sometimes referred to as *wild goose chases*, in which one rider set a course across country pursued by others, whose object was to catch the leader.

Steeplechasing involves jumping and flat racing. It had its origins on the hunting fields of the eighteenth century. In Great Britain, Ireland, France and the United States, steeplechasing has risen above the level of a minor sport. In these countries it continues to be a popular equestrian pursuit.

Point-to-Point

Hunt racing courses today vary from round to oblong, from oval to triangular, even including a figure-eight, but all have one attribute in common: horses competing over them must end up where they started.

This was not always the case. Originally, a point-to-point race was just that: it was run from point A to point B, with the first to arrive at the goal the winner. It used a more direct course than steeplechasing, with which point-to-pointing shares a common ancestry. Both grew out of the eighteenth-century hunting field, evolving from the private matches with which sportsmen amused themselves out of season. Such matches were usually headlong cross-country gallops intended to prove one's hunter better than the other fellow's, most having a hefty wager at stake.

Point-to-point racing evolved to become the professional sports of steeplechasing and hurdle racing that we know today. The point-to-point race retained much of its association with hunting and amateur riding, with riders wearing hunting dress, and courses across natural country, with no specially built jumps.

Harness Racing

Harness racing is one of the oldest horse sports. Chariot racing existed in Roman times, and probably in the days of the Greeks, Egyptians and Assyrians. Various forms of harness racing now take place all over the world, particularly in Europe, the United States, Canada, Australia and New Zealand.

From its early origins, harness racing has evolved into trotting and pacing. In both forms, a single horse pulls a very light sulky and is guided by one driver. Trotters move diagonally, as horses generally do, while a pacer's legs move forward together, followed by the two offside legs.

Trotting developed at the end of the eighteenth century and

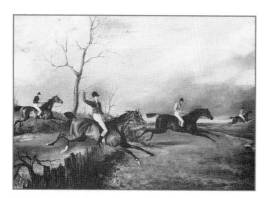

Steeplechasing. *George Henry Laporte. 1831.*

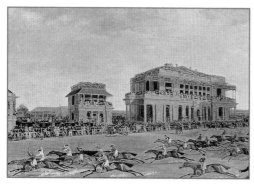

Racing at Doncaster, England. c.1780.

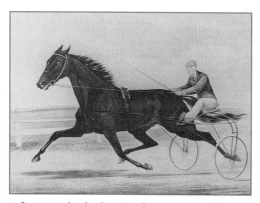

A fine example of a champion harness racer. 1896.

flourished around the first half of the nineteenth. At first, trotting matches took place under saddle but, with the development of fast carriages, they were raced in harness. The conformation of a good harness racehorse varies from that of a Thoroughbred. The most important criterion is that the harness horse does not have to carry the weight of a rider on its back.

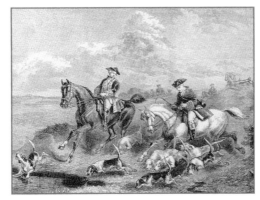

Hunting with the hounds. *Frederick Taylor. 1872.*

Hunting

Hunting became a sport when it was no longer needed to provide food for the larder. It is consequently the oldest equestrian sport, but killing the quarry is not now the basic aim. The catalyst for the sport were the Enclosures Acts passed by the British Parliament beginning in the early eighteenth century. That legislation required landowners to separate private property from common land, and the fences, walls, hedges, and banks and ditches were inviting obstacles for the sporting set to jump. As an added benefit, farmers were pleased to see the countryside rid of the predators that raided their chicken coops.

British colonists brought fox hunting to North America, where it became especially popular in the Middle Atlantic states. Important packs were established in New England and the South.

Stag hunting, which has the earliest origins, is not commonly practiced today except for a few packs in the British Isles and in France, where it is still very popular. In English-speaking countries, fox hunting has the largest number of packs and followers. In areas where fox hunting is difficult, drag hunting, in which the hounds follow a scent laid on by means of a drag over prepared country, is gaining popularity. Coyote, wild boar, hares, and rabbits are hunted from horseback. Whatever the quarry, the etiquette, preparation and procedure for hunt-followers is similar, based on traditions that have grown up over hundreds of years.

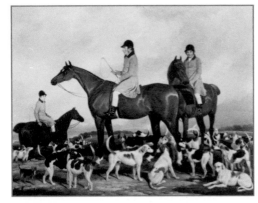

The Old Surrey Foxhounds. *William & Henry Barraud. c.1845.*

Endurance Riding

The Wells Fargo Company, famed in many a Western film, owed much between 1872 and 1892 to its President, Lloyd Tevis, who developed the renowned delivery and mail company with its express riders, stages and fleet horses. Closely allied with Tevis was James B. Haggin, a breeder of fine racing stock, successful in California during the days of the gold rush. From this historical background America's most famous annual 100 mile endurance ride takes its name as well as its premier award, the Tevis Cup, and an award for the best-conditioned horse, the James B. Haggin Cup.

This new phase of horsemanship was established in America by the end of the nineteenth century and became increasingly popu-

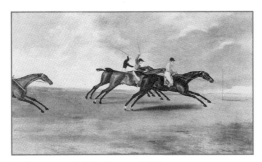

Racing scene. *Edwin Cooper. 1804.*

lar in Great Britain and Australia. Endurance racing is possibly the only equestrian event in which the initial competition is against the rider's own preparation and training, rather than other riders.

Western Events

Western riding encompasses activities involving livestock equestrian techniques, evolved from strictly functional beginnings: the working of herds of cattle on the ranges of the American West. Horses used in Western riding are usually quarter horses, Appaloosas, Paints, Morgans and Arabians, or crosses between these breeds or grades. Riding styles are based on classic Western horsemanship, and riders must be attired in Western wear.

The American Horse Shows Association Western Division competition comprises three sections: Stock Horses, Western Trail Horses and Western Pleasure Horses. These make up the horses and events known as Western.

In addition, competition has more recently been added in Parade Classes, the American Quarter Horse Halter Division and the alert and agile Cutting Horse contests.

Rodeo Events

The word *rodeo* is Spanish for "roundup," and this truly American sport had its origins in that cowboy activity. After the roundups, when ranch hands gathered to relax, talk turned to who could rope a steer the fastest or ride the meanest bronco. The only way to find out was by trying, and the resulting informal contests became popular throughout the West. In the latter decades of the last century, cities began to sponsor events, prize money was offered, and the sport was formally established. Five events constitute the most traditional and widely seen rodeo activities: calf roping, saddle bronc riding, bareback bronc riding, bull riding and steer wrestling, or bulldogging. Only the first has contemporary application to ranch work.

Competition

Show-jumping

Show-jumping is a newcomer to the world of equestrian activity. It was first mentioned in a French cavalry manual toward the end of the eighteenth century, when standing leaps were the norm. Not until the 1860s are there records of organized show-jumping competitions. In Ireland, the Royal Dublin Society's show of 1865 included a high-and-wide leaping competition. The following year there was a jumping competition in Paris, which was nearer to cross-country than to show-jumping. After a preliminary

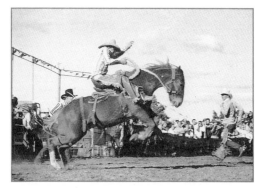

Bucking bronco at a rodeo.

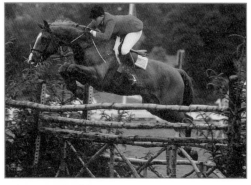

A fine example of show jumping.

parade indoors, the competitors were sent out into the country to jump over mostly natural obstacles.

On the Continent, jumping quickly became widespread, particularly in Germany and France, where jumping competitions were included in the 1900 Olympic Games held in Paris. In Turin, Italy, in 1901, officers from the German army were invited to take on their counterparts in the Italian army in a jumping contest. The era of international show-jumping had begun, though it is unlikely that any of the pioneers of the sport envisioned its spectacular growth.

Combined Training (Eventing)

Three-day event competitions are perhaps the most demanding and rewarding of any equestrian activity. In order to do well, a horse must combine speed, stamina, obedience and considerable jumping ability. Its rider must be knowledgeable and expert in three distinct branches of horsemanship: dressage, cross-country riding and show-jumping. The object of combined training is to test the all-around quality and versatility of the horse.

Combined training is the modern English term for what the French have always known as *concours complet*—the complete test.

It all began with Xenophon in 400 B.C., who instructed his cavalry commanders to train their horses for long distance endurance. Over the centuries the great horsemasters evolved systems of training and riding horses which were adopted in whole or in part by cavalrymen, who placed much emphasis upon endurance.

The French developed the first true precursor of the modern three-day event, the *Championnat due Cheval d'Armes*, staged by the cavalry near Paris in April 1902. Like other competitions at this time, the *Championnat* was an entirely military affair. It was open to one officer from each regiment of the army. The competition was designed to produce an all-around horse and rider, reducing the tendency to over-specialize, and aimed at improving the type of horse being bred and the standard of riding and training.

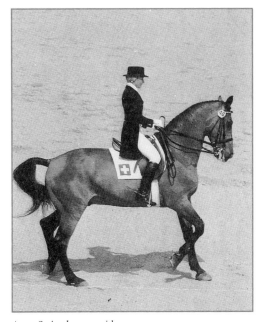

A top Swiss dressage rider.

Dressage

As with almost every other form of physical activity, the art-sport of dressage has long since taken its place in the competitive sphere. Dressage comes from the French, literally translated as *training*. Dressage has been described as "the gradual harmonious development of the horse's physical and mental condition with the aim of achieving the improvement of its natural gaits under the rider and a perfect understanding with its rider."

Riders have enjoyed dressage for centuries. High School (advanced dressage) enjoyed a great vogue in the courts of Europe

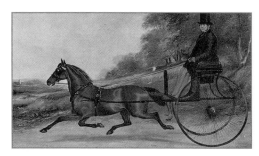

Sir Joseph Hawley. c.1865.

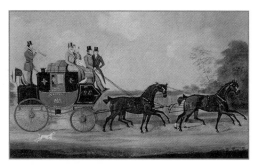

Coaching scene. *Edwin Cooper. c.1810.*

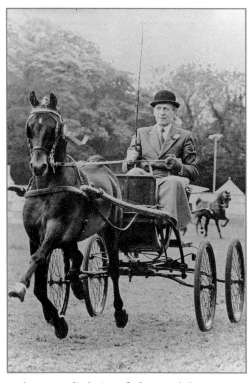

Hackney pony displaying a flashy extended trot.

during the Baroque era. To ride a horse well was considered an essential attribute for the nobleman. Musical rides were organized to entertain onlookers and to give riders the challenge of producing performances of a higher standard.

Driving

Driving a horse harnessed to some form of carriage appears to have been a sport as well as a means of conveyance for more than 3,000 years. The Greek and Roman charioteers were perhaps the earliest exponents of driving more than one horse as fast as possible. In England, wagering on nearly every activity was a major sideline among sportsmen during the seventeenth and eighteenth centuries, and it was not long before horses, ridden as well as driven, were exploited by their owners, who earned considerable sums of money by this means.

By the late eighteenth century driving had become a fashionable pastime. The fashion for driving led to the formation of several driving clubs and organized competitions.

Often, post boys were used to supplement or replace the drivers seated in their carriages. Riding astride a carriage horse, mostly at a trot, required the rider to learn a new art. Drivers found the trot to be the most economical pace because of its ability to cover considerable distances at ever-increasing speeds. For the rider, however, trotting was very uncomfortable until riders learned to use their stirrups and to rise, or post, to the trot. In this way the rider followed the horse's natural movements and the typically extended excursions became a great deal more comfortable.

Though the appearance of the railways virtually put an end to coaching as a means of travel, the desire to drive four horses remained, and a revival of the sport took place with many old stage coaches being run on their original routes. This practice was followed by driving competitions with competitive events as well as races against the clock.

These competitions involved the negotiating of small obstacles such as driving through narrow markers, stepping over raised poles, and backing into and out of gateways for all types of harnesses including pairs, four-in-hands and teams of up to twelve stallions in hand.

Games

The world's most popular game played on horses is polo. The word polo comes from the Tibetan word pulu, which means "root" or "ball." It was played in Persia as early as 600 B.C. From there it became popular in India and Tibet, where it was played with as

many players as the field could accommodate. Paintings depict early polo players as both men and women. In the nineteenth century, British Army officers in India took up the sport and soon brought polo to Europe. In the beginning, in central Asia, the popular game was played by teams of twenty or more, and several teams could play at the same time. Whips with wooden handles were carried, but only for hitting opponents, not their ponies. The area was unlimited, but single goalposts stood about a half a mile apart, and rocks and precipices were desirable hazards. The goatskin ball was thrown in, picked off the ground by a mounted rider and tucked under the knee.

In 1868, polo was introduced into the western world by the English, in a match between cavalry officers. Polo grounds were soon established throughout the London area. With its refined strokes, tactics and style of play, polo soon became a highly fashionable game, an integral part of the London scene.

Polo was first played in the United States in 1883, at Meadow Brook, New York. Perhaps because of the Europeans' preoccupation with pure equitation, polo was never played on the continent on as large a scale as in England or the United States. In South America the Argentines, with their great wealth, their natural talent for ball games and their ranch ponies (*criollos*), soon emerged as the leaders of the polo world.

Conclusion

No other animal in history has made itself so useful and so often indispensable to man as the horse. For centuries, its sturdy back and fleet limbs provided the most satisfactory means of transportation, communication, cultivation and national security. Then, as machines began to perform these functions more efficiently, the horses's traditional role radically changed. Today the majority of horses are kept primarily for sport and pleasure.

The popular pursuit of horsemanship, as we know it, has evolved from an elite pastime of royalty to a world-class competitive sport that boasts millions of participants and spectators internationally. The illustrations in this volume bring to light a period of popular cultural art that influenced changes in public perceptions of riding. These early years were exciting and dynamic in their visual presentations as the pursuit of horsemanship is in its appeal to the millions who adore it.

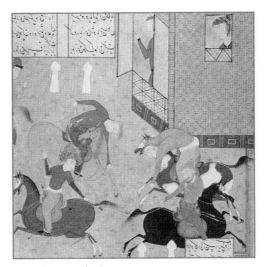

An early game of polo.

Princess Hamai playing polo.

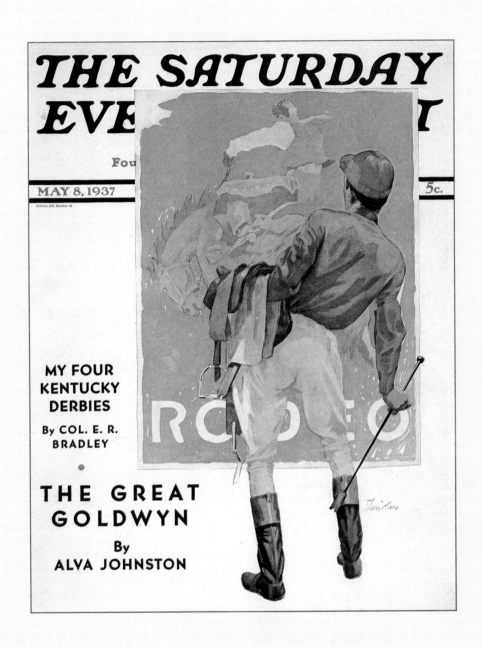

The Saturday Evening Post. *Sheridan. 1937.*

HISTORY OF MAGAZINE ILLUSTRATION

"A work of art cannot be satisfied with being a representation, it should be a presentation."

Jacques Reverdy
French artist,
twentieth century

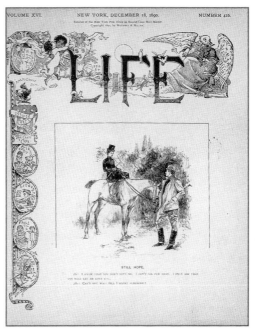

Life. *1890.*

*T*he first magazines were published in France in 1665. Others soon followed around the world, and they were typical of the visually dry and textually dull publications that appeared during the first 200 years of magazine history. Most publishers did not realize the significance of visuals as tools to educate, shape opinions, entertain, and sell greater numbers of their magazines.

In the mid-nineteenth century the magazine began to change from an elitist publication to the main source of popular entertainment for the general public. Instead of speaking primarily to the well-educated upper classes, the magazine addressed a broad cross section of the population. Aided and inspired by the cultural and technical changes of the Industrial Revolution, the new, modern magazine enjoyed a dramatic rise in popularity in Europe, the United States and elsewhere. By 1890 it had begun its most colorful period.

Through the addition of illustrations, the periodical achieved a new character and vitality in the Victorian Age. With the emergence of the magazine, art could be disseminated to substantial numbers of people for the first time in history.

Until that time all art forms had been relatively inaccessible to the general public, remaining in the hands of privileged friends and patrons of the artists or publicly displayed in faraway cities. Sports involving horsemanship were likewise generally inaccessible up to this time. As the public's appreciation of art grew, the magazine proved to be an important stage upon which artists of all kinds could depict the horse in all its romantic glory.

The magazine cover, like the magazine itself, had been neglected as a decorative element in its early years. But with the increase in vivid dramatic illustrations came the discovery that the magazine cover had important powers to influence and amuse.

Great Britain took the early lead in producing illustrated periodicals during the nineteenth century. Publishers, as well as master engravers and artists, sensed the public's readiness to spend

a shilling a copy to enjoy the latest illustrations, which were often eyewitness accounts of current events.

There are two apparent reasons for the emergence of Great Britain as the early leader in the production of illustrated periodicals and books: its efficient communications system for distribution of publications and its educated public to read them. However, other countries soon began to catch up with and eventually surpass Great Britain in the visual arts.

With the emergence of *Frank Leslie's Illustrated Weekly* and *Harper's Weekly*, the modern illustrated periodical was born in America. American marketing ingenuity created the link that delivered the magazine into the hands of vast numbers of people.

The late nineteenth century was a time of great social change. Traditional class structures were being eroded. Magazines were an important focus for people as they experienced a shifting of social values. Horsemanship was brought to light through accounts and illustrations of early visitors to England, Wales and elsewhere.

Perhaps the 1890s should have been called the *more decade.* The nineties brought more money, more leisure, education, sports and entertainment. As travelers discovered riding, it followed that illustrations of horsemanship would be extensively offered to the magazine public.

Production of magazines went through revolutionary changes during the late nineteenth century. Until that time, it was a difficult, time-consuming and costly task to produce the visuals accompanying magazine text. Publications would often share the $300 to $500 cost for a full-page woodcut with other publishers. This prohibitive cost was reduced as technological changes made economies of scale possible. At the same time technological changes in equestrian equipment led to economies of scale and that began to lower the costs of riding as a pastime.

A typical magazine illustration took three weeks to complete in the mid-nineteenth century. By 1872 the process of making an illustration from start to finish took one week. Ten years later it had been refined to two days, and by 1900 shortened to a few hours. Photoengraving came into use about this time, radically reducing the time and cost for producing magazine graphics. It reduced a long laborious process to a simple, mechanical one.

In addition to photography, the other important technical advancement for magazine illustrations was the color revolution. Color lithography enabled magazines to display beautiful works of art with a quality never dreamed possible by most people. The color

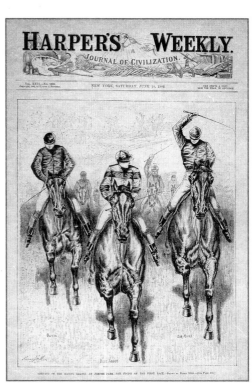

Harper's Weekly. *Henry Stull. 1882.*

revolution produced intensified public interest in prints, posters and magazine covers. As a result, important artists such as Will Bradley, Edward Penfield, Charles Dana Gibson and Maxfield Parrish were drawn to these media. Other famous illustrators included Harrison Fisher (The Fisher Girl), Howard Chandler Christy (The Christy Girls), Jessie Wilcox Smith (wide-eyed children), and Norman Rockwell (all-American scenes).

Magazines used vivid illustrations to attract readers, showing equestrian sports in all their picturesque beauty, depicting people from all walks of life enjoying the thrill and grace of these sports.

Looking at magazine covers, one can understand the important interaction between the magazine and fine art. Clearly, the magazine, and its cover in particular, comprised an important medium allowing many remarkable artists to test their artistic and experimental works in public. The cover also became a medium through which fine art was diffused into a more commercial form, more readily available to the masses.

During the early decades of the twentieth century, the magazine industry flourished. Since radio did not enter most households until the early 1920s, magazines enjoyed a captive market. There were fears, of course, that the popularity of radio would completely smother the magazine industry. Fortunately, it did not.

One of the keys to the success of magazine publishing was the increase in advertising, which helped lower the public price of each magazine, which in turn, boosted circulation. Advertisers pumped large sums of money into the industry, as they discovered that the buying power of the rising middle class could best be tapped through magazine advertising.

The biggest effect felt by the magazine industry in the 1930s was not that of the Depression or international political tension, but the publication in the United States of *Life* magazine in 1936. With 96 pages of photographs and only a minimum of text, *Life* brought photo-journalism into unprecedented importance, as the photographer took the magazine cover away from the illustrator.

The introduction of photographic accounts proved to be decisive, signalling the beginning of the end of the predominance of magazine illustrations. But it was also decisive in bringing forth a new awareness and public enthusiasm for modern riding.

The Literary Digest. *R. Farrington Elwell. 1920.*

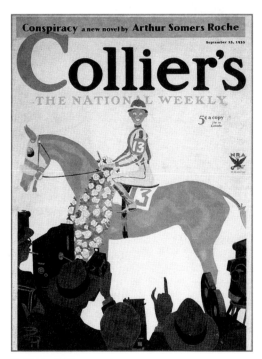

Collier's. *1933.*

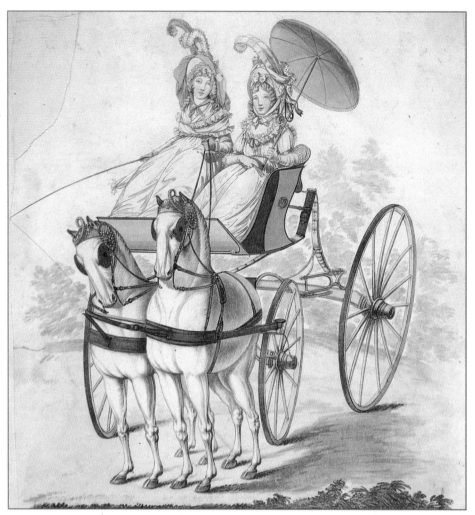

England. 1794.

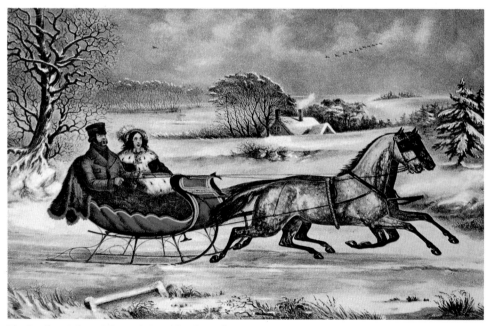

The Road, — Winter. Woman's Day. *Currier and Ives. 1853.*

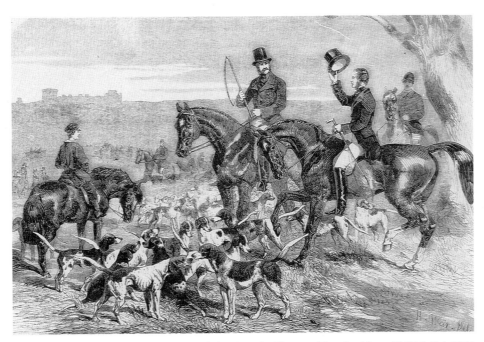

H.R.H. Prince Albert's harriers. The Illustrated London News. *H. Weir Del. 1856.*

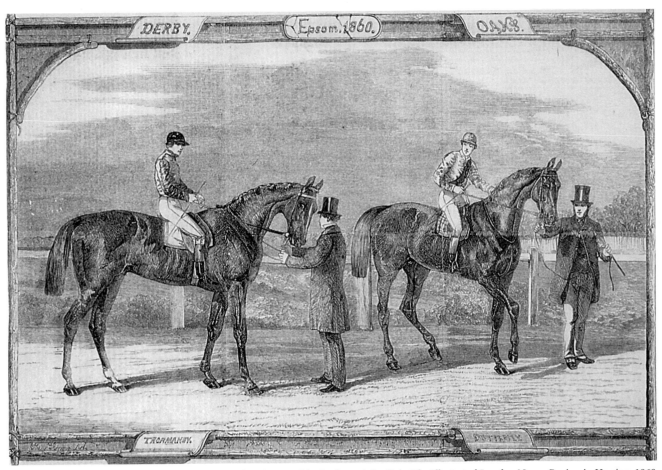

The winners of the Derby and the Oaks. The Illustrated London News. *Benjamin Herring. 1860.*

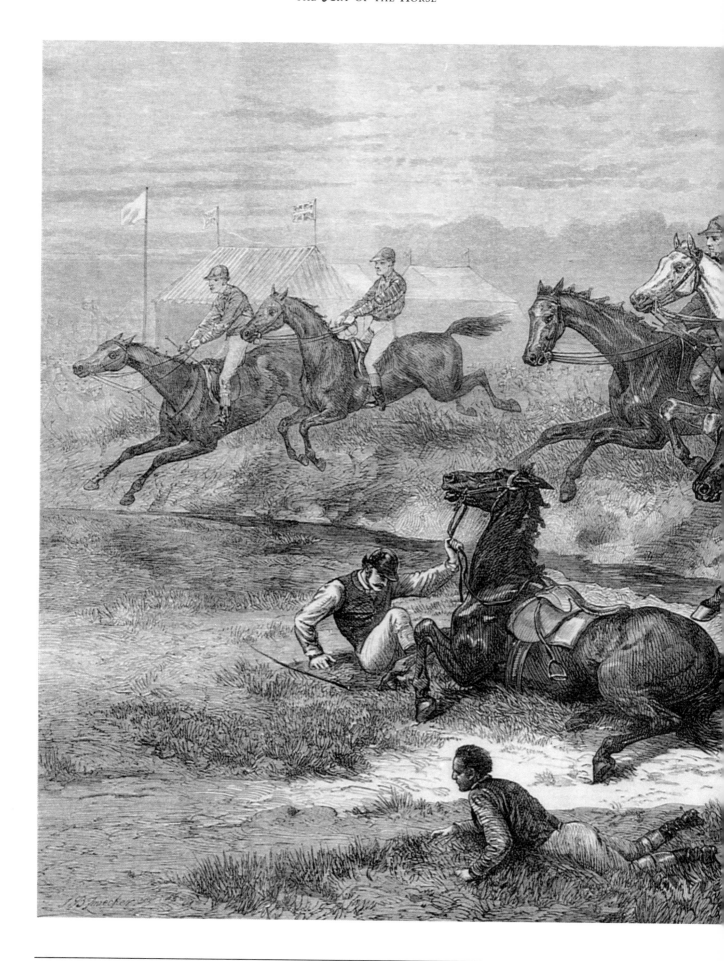

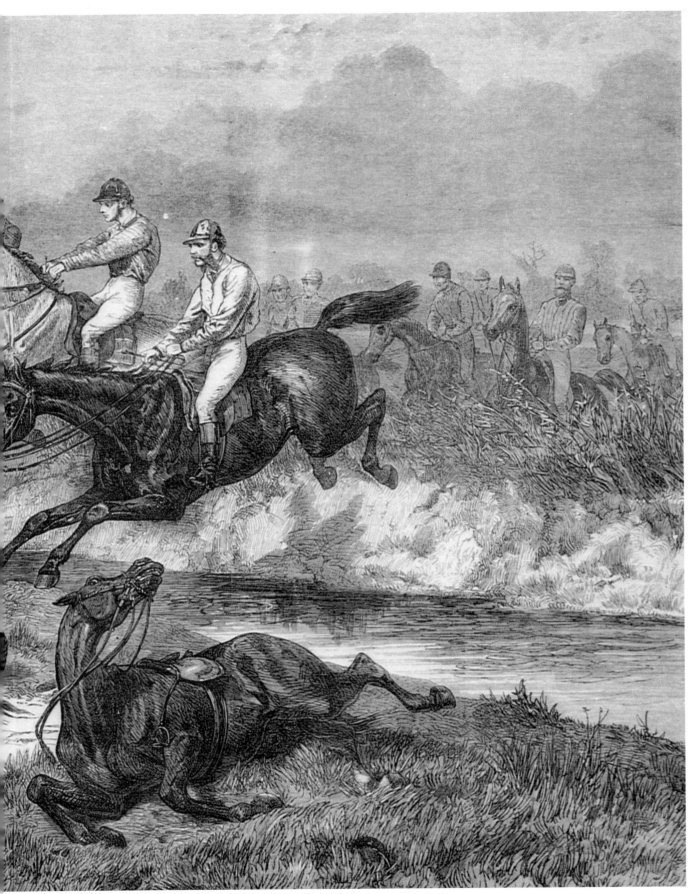

A steeplechase. The Illustrated London News. *1873.*

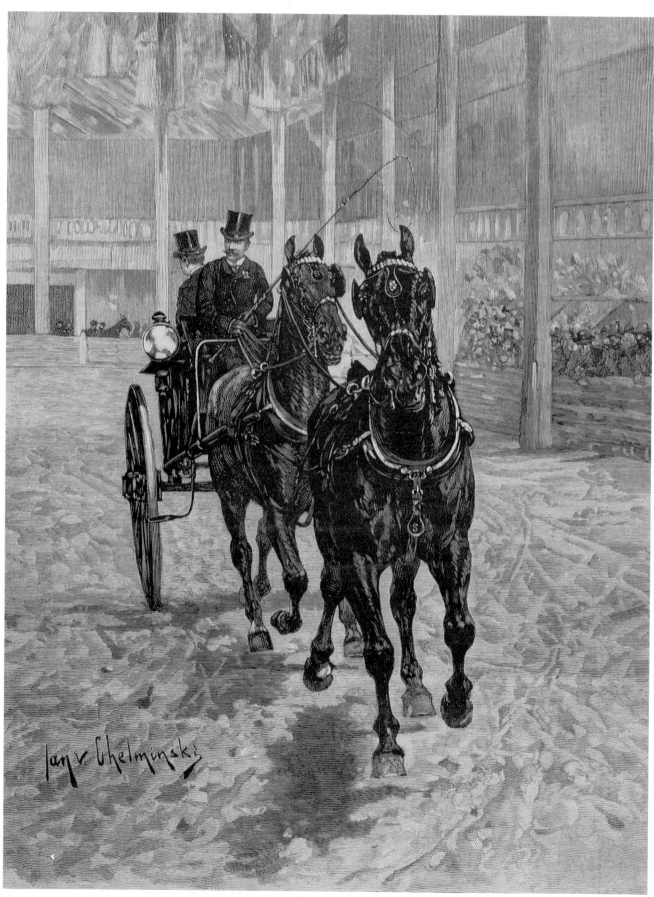

At the horse show. Harper's Weekly. *Jan v. Chelminski. 1886.*

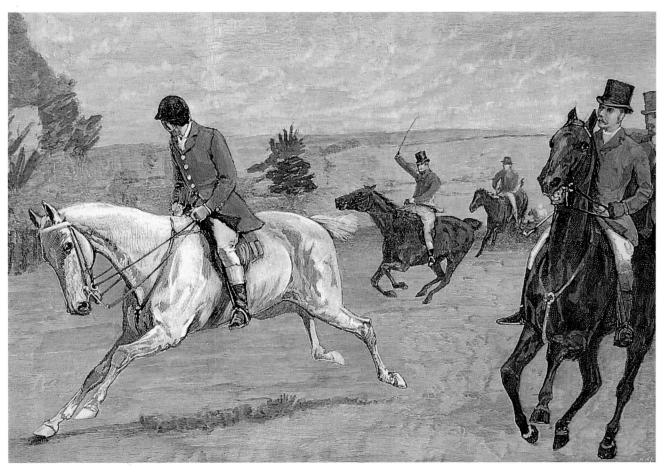

House of Commons Point-to-Point steeplechase near Daventry. Harper's Weekly. *c.1885.*

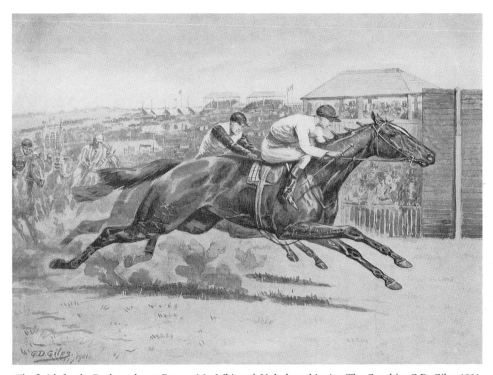

The finish for the Derby stakes at Epsom; Mr. Whitney's Volodyovski *wins.* The Graphic. *G.D. Giles. 1901.*

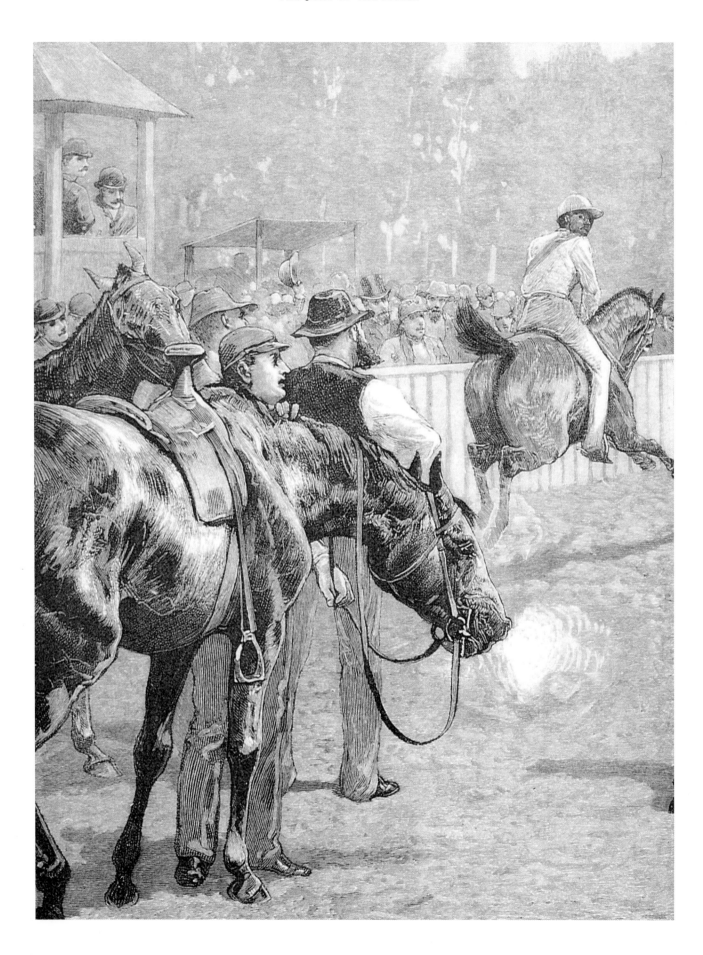

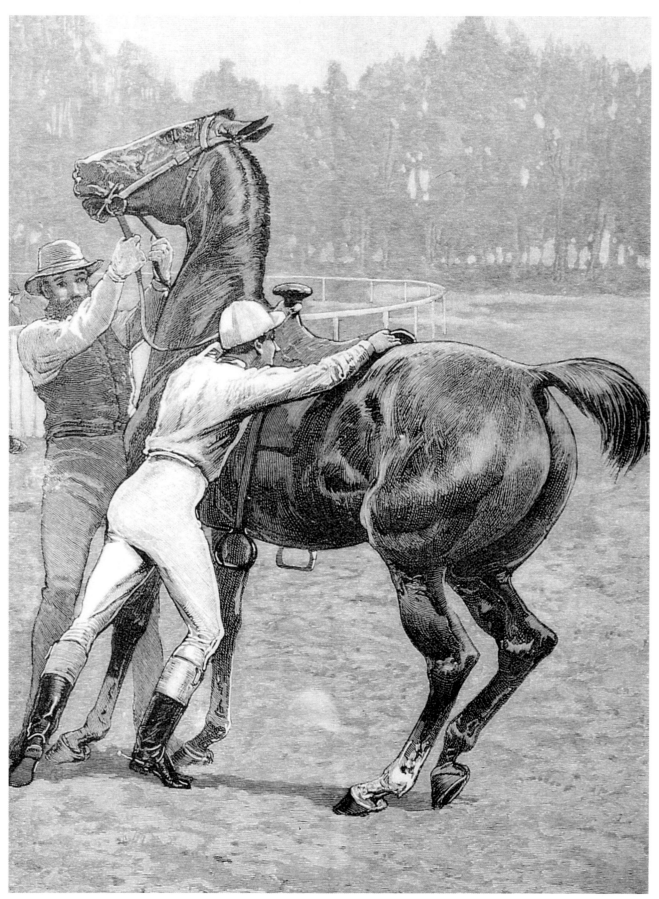

A thirty-mile race at Los Angeles, California — changing horses. The Graphic. *1889.*

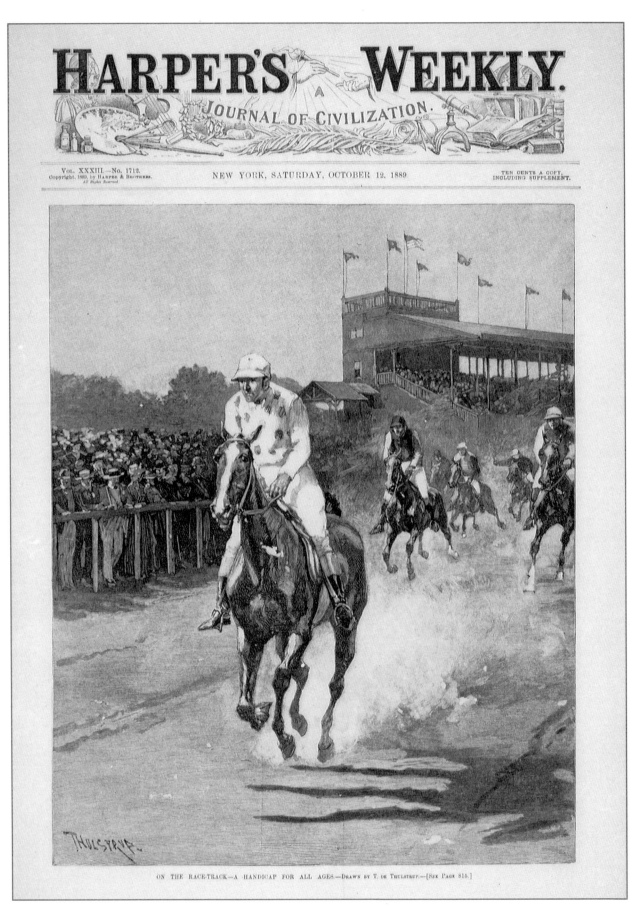

Harper's Weekly. *T. de Thulstrup. 1889.*

Vol. XXXVII.—No. 1926.
Copyright, 1893, by Harper & Brothers.
All Rights Reserved.

NEW YORK, SATURDAY, NOVEMBER 18, 1893.

TEN CENTS A COPY.
FOUR DOLLARS A YEAR.

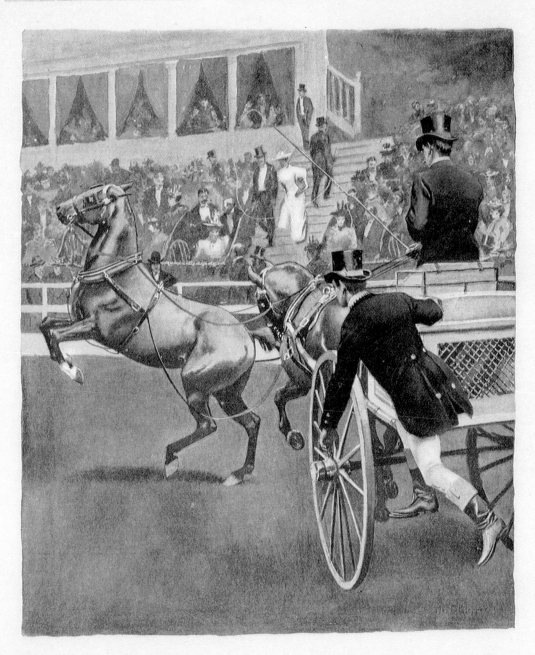

THE NEW YORK HORSE SHOW—A TANDEM IN TROUBLE.

DRAWN BY MAX F. KLEPPER.—[SEE PAGE 1099.]

Harper's Weekly. *Max F. Klepper. 1893.*

Frederick Archer, the celebrated jockey, on Bend Or.
The Illustrated London News. *1886.*

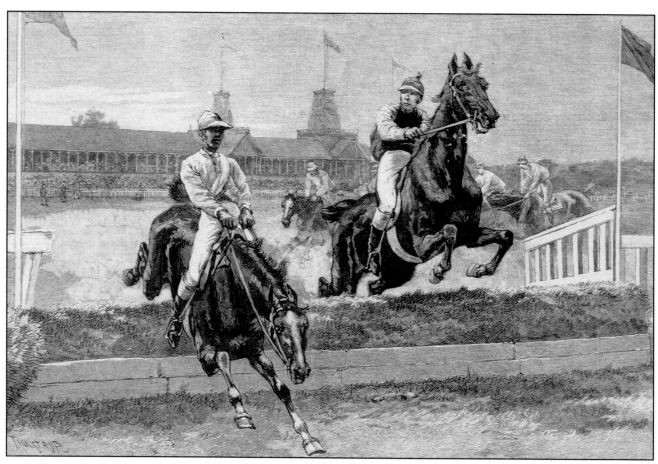

A steeplechase at Monmouth Park. Harper's Weekly. *T. de Thulstrup. 1885.*

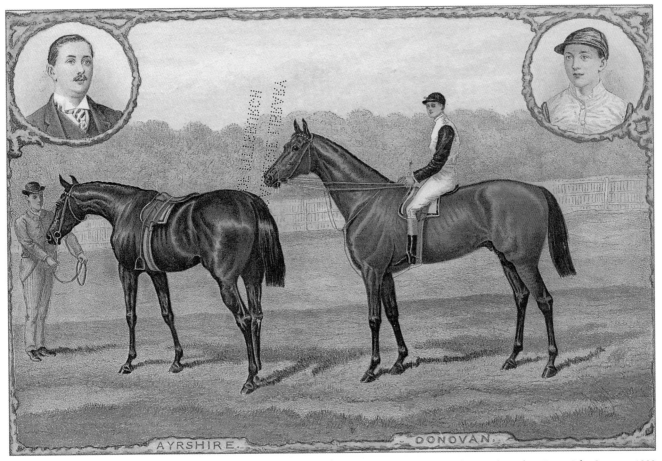

Duke of Portland's Derby winners. The Illustrated London News. *John Sturgess. 1889.*

Steeplechasing — The last fence — Before. The Graphic. *1874.*

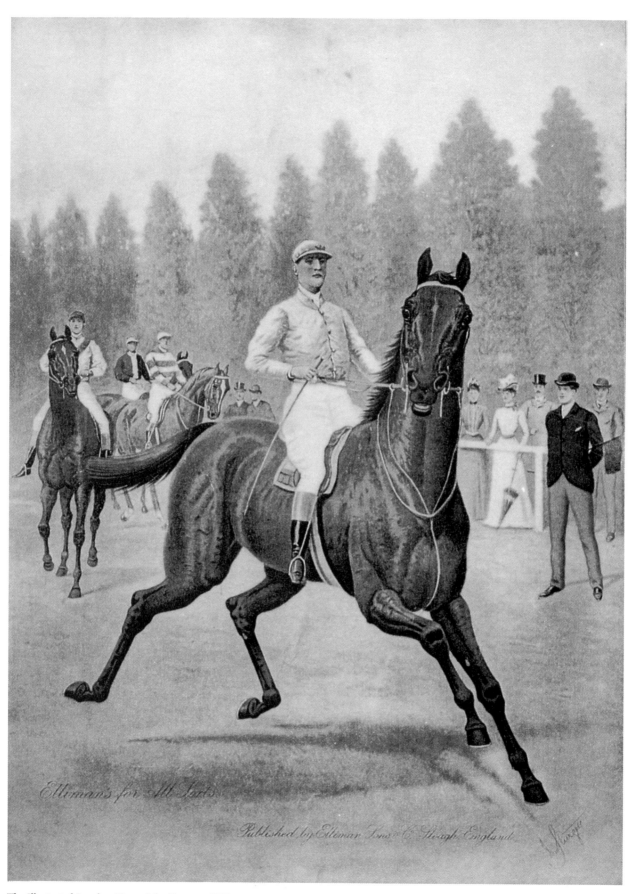

The Illustrated London News. *John Sturgess. 1902.*

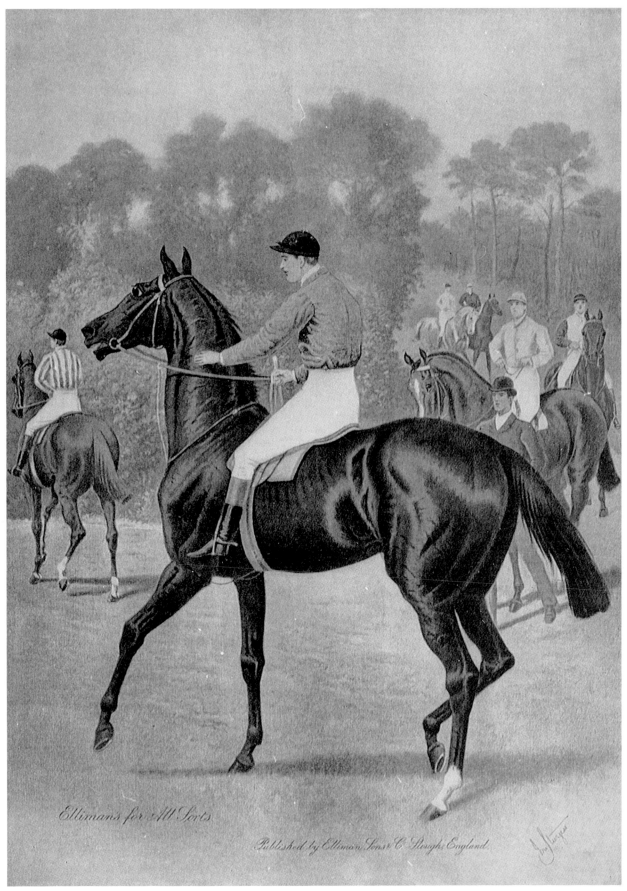

Ellimans for All Sorts

Published by Elliman Sons & C Slough England.

The Illustrated London News. *John Sturgess. 1902.*

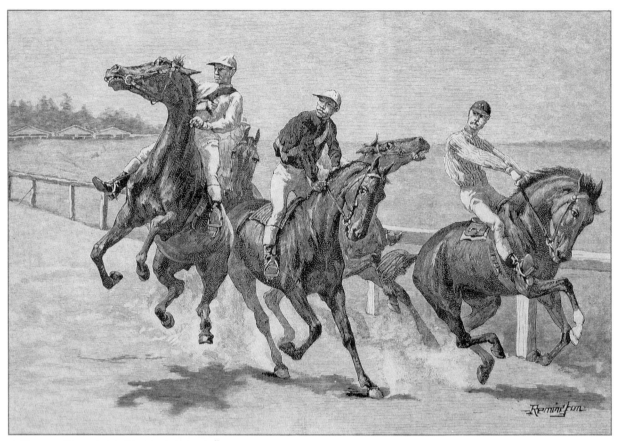

A false start. Harper's Weekly. *Frederic Remington. 1887.*

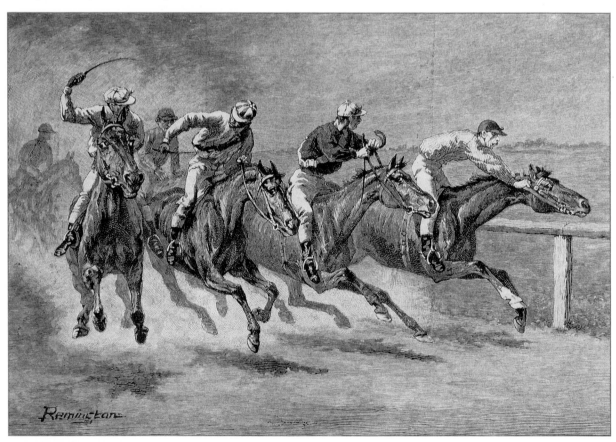

A close finish. Harper's Weekly. *Frederic Remington. 1887.*

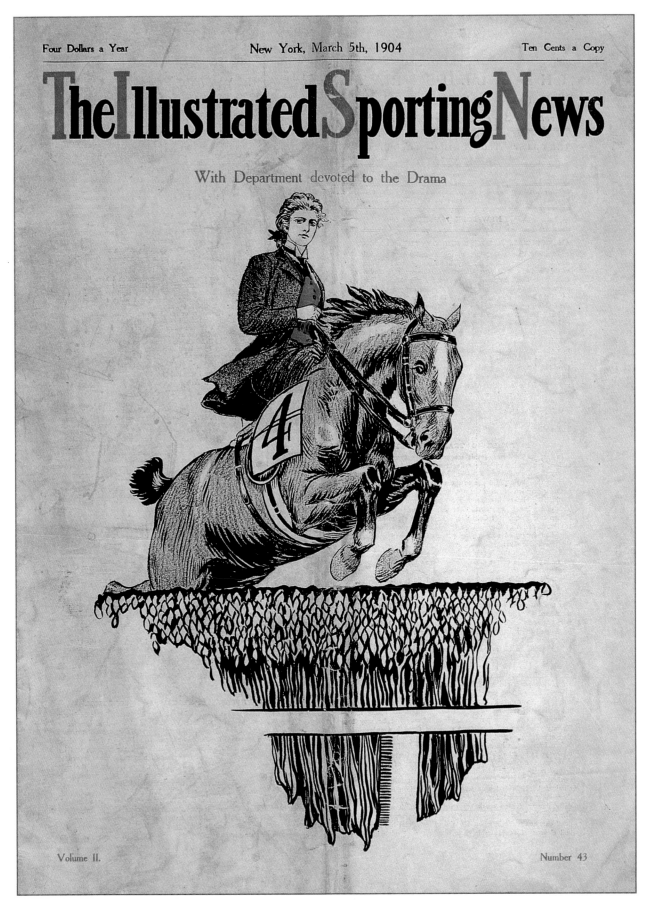

Four Dollars a Year

New York, March 5th, 1904

Ten Cents a Copy

The Illustrated Sporting News

With Department devoted to the Drama

Volume II.

Number 43

The Illustrated Sporting News. *1904.*

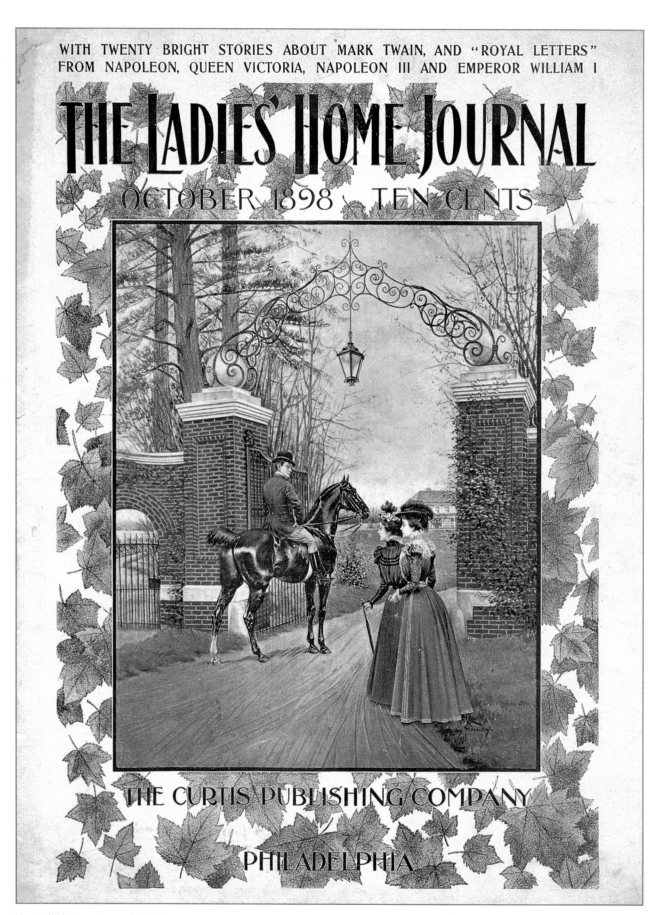

The Ladies' Home Journal. *1898.*

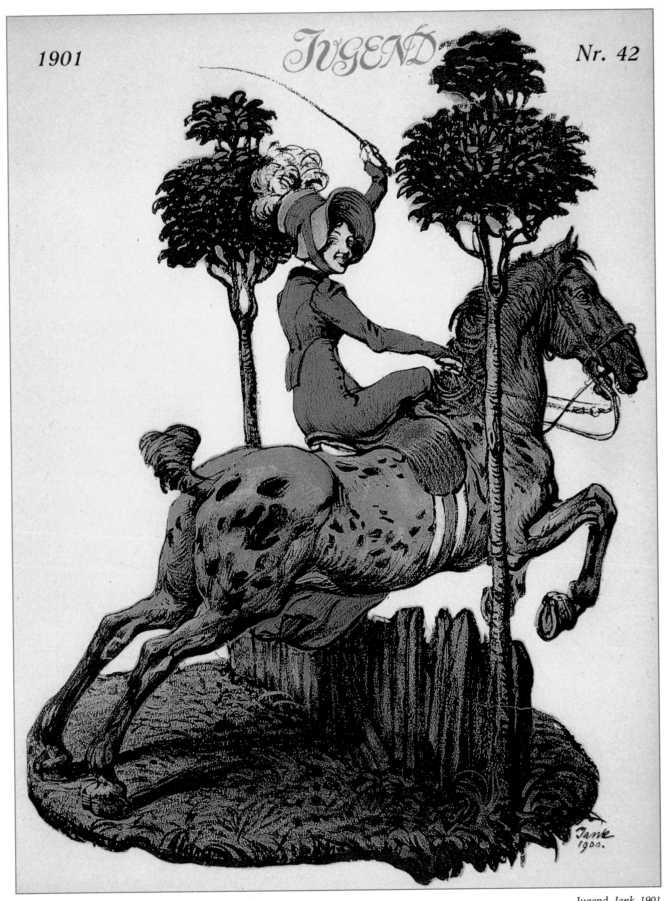

Jugend. *Jank. 1901.*

A. Russell. Germany. 1912.

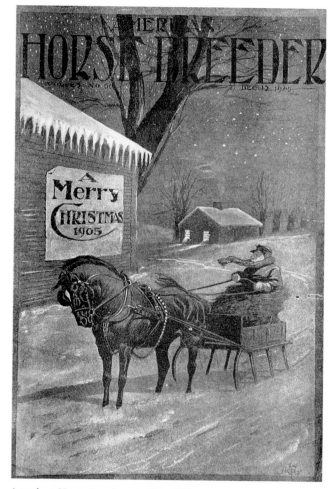

American Horse Breeder. *Dunffey. 1905.*

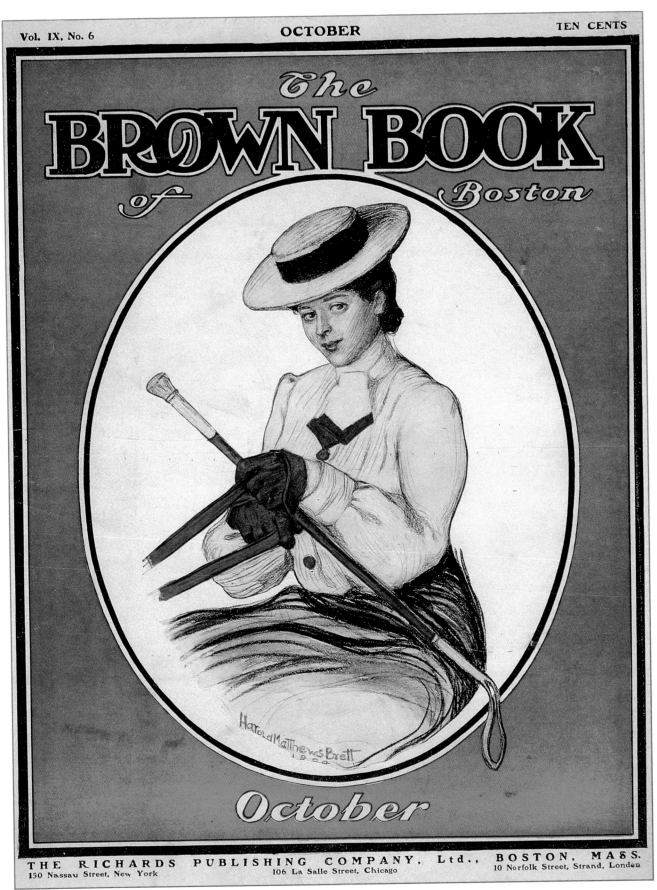

Vol. IX, No. 6 OCTOBER TEN CENTS

The
BROWN BOOK
of
Boston

October

THE RICHARDS PUBLISHING COMPANY, Ltd., BOSTON, MASS.
150 Nassau Street, New York 106 La Salle Street, Chicago 10 Norfolk Street, Strand, London

The Brown Book of Boston. *Harold Matthews Brett. 1904.*

The Sport of Autumn: Cub-Hunting. J.S. Sanderson Wells. c.1910.

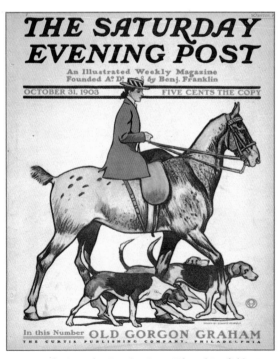

The Saturday Evening Post. *Edward Penfield. 1903.*

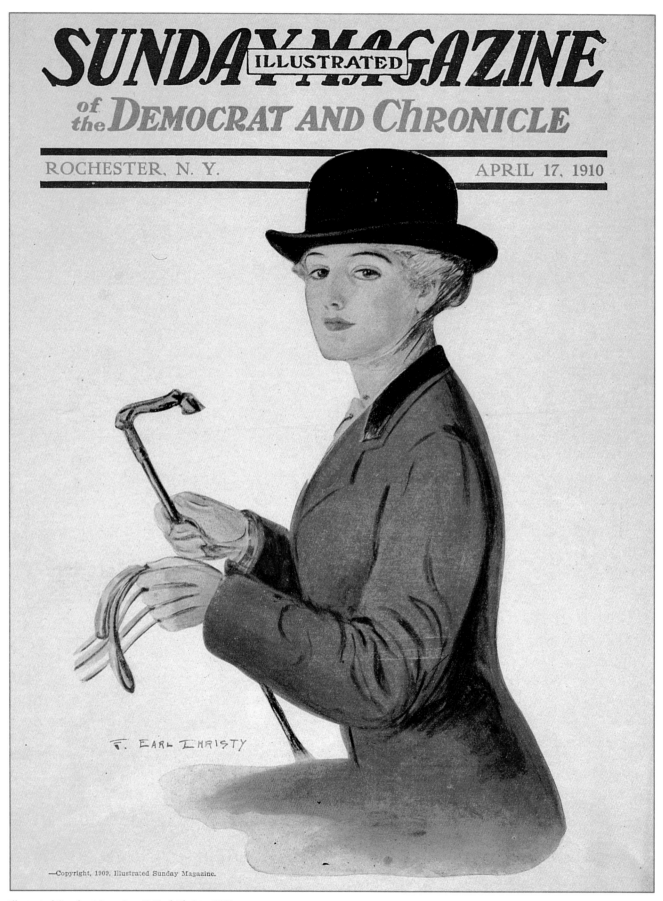

SUNDAY ILLUSTRATED MAGAZINE
of the DEMOCRAT AND CHRONICLE

ROCHESTER, N. Y. APRIL 17, 1910

F. EARL CHRISTY

Illustrated Sunday Magazine. *F. Earl Christy. 1910.*

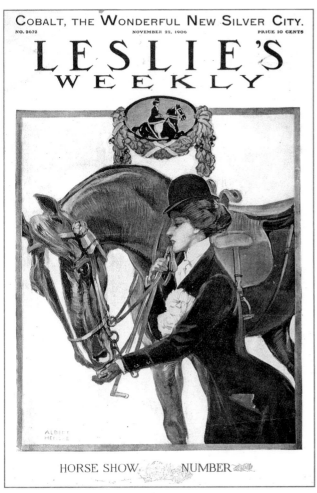

Leslie's Weekly. *Albert Hencke. 1906.*

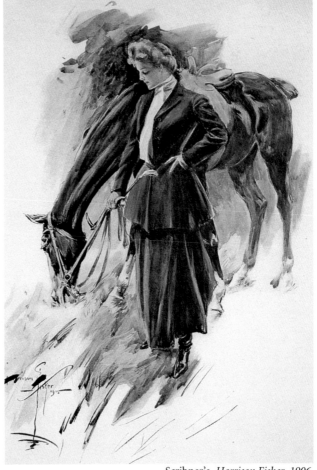

Scribner's. *Harrison Fisher. 1906.*

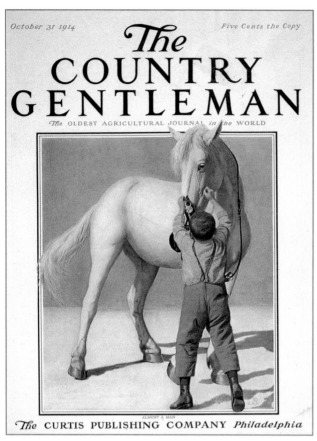

The Country Gentleman. *1914.*

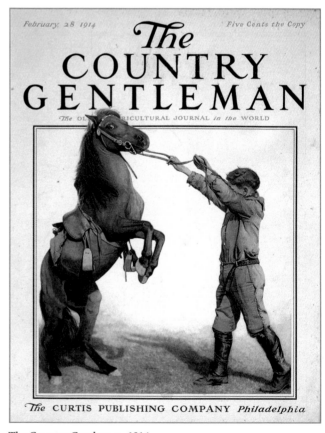

The Country Gentleman. *1914.*

May 17 1913 Five Cents the Copy

The COUNTRY GENTLEMAN

The OLDEST AGRICULTURAL JOURNAL in the WORLD

The CURTIS PUBLISHING COMPANY Philadelphia

The Country Gentleman. *1913.*

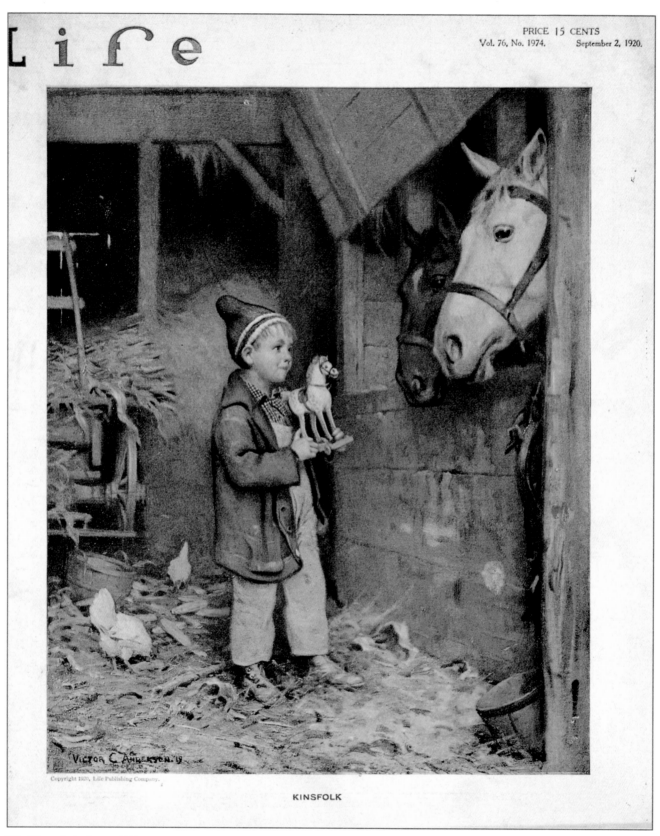

KINSFOLK

Life. *Victor C. Anderson. 1920.*

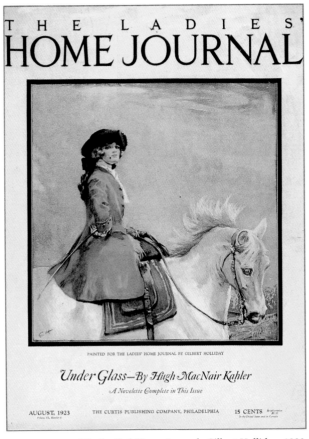

The Ladies' Home Journal. *Gilbert Holliday. 1923.*

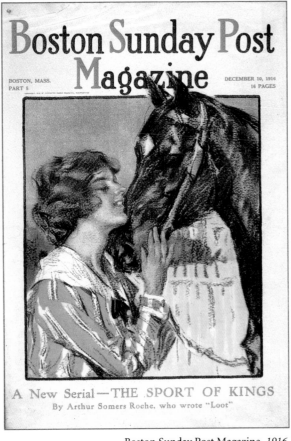

Boston Sunday Post Magazine. *1916.*

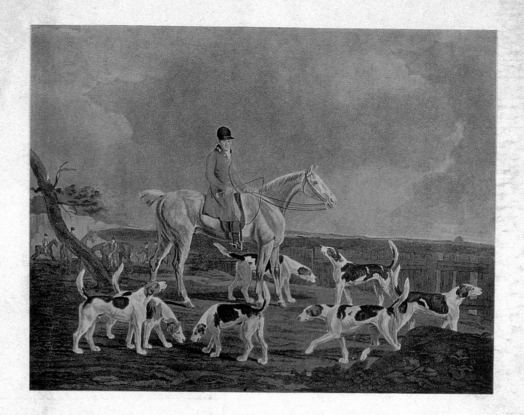

OCT 1 - 1929

The FIELD

**COUNTRY ESTATES · LANDSCAPING
ARCHITECTURE · DECORATIONS
HORTICULTURE · BREEDING
SPORTS · AVIATION · PERSONALITIES
TRAVEL & EXPLORATION**

PUBLISHED BY FIELD PUBLICATIONS, INC., NEW YORK, N. Y.

The Field. *1929.*

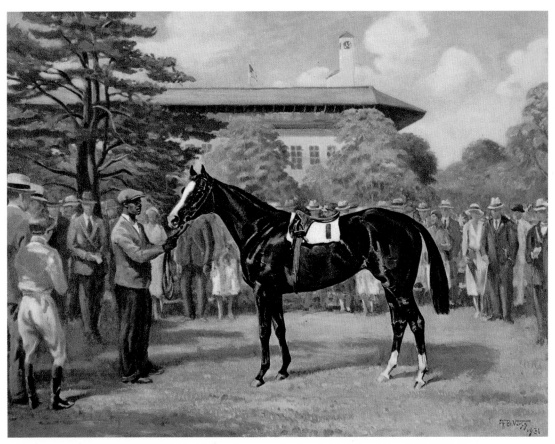

Top Flight. *F.B. Voss. 1931.*

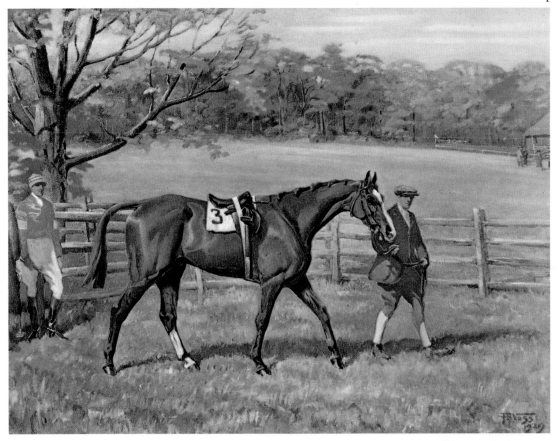

Alligator. *F.B. Voss. 1929.*

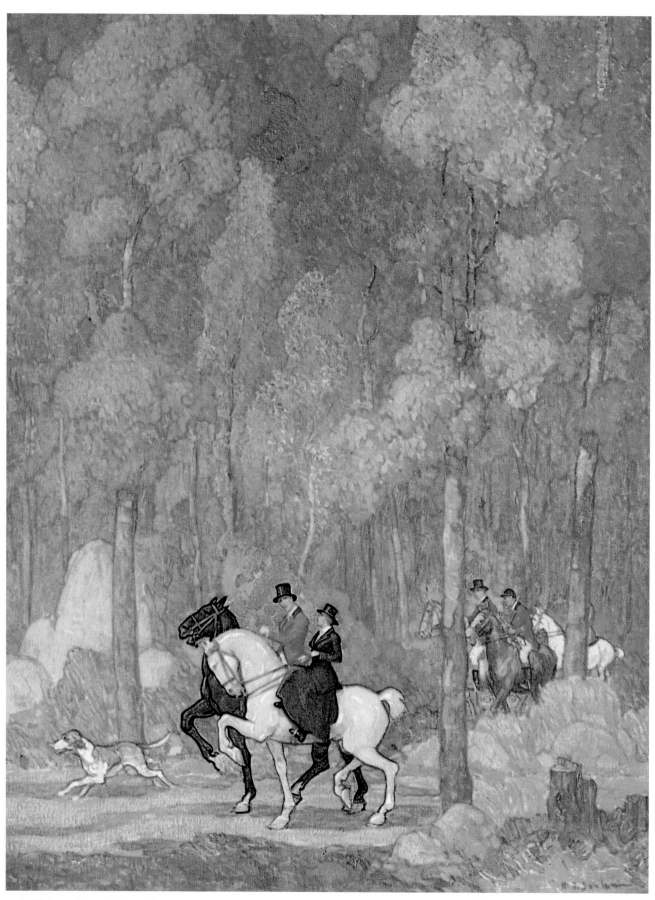

He had fallen in love with her, at first sight, on the Brookside hunt. The Saturday Evening Post. *Henry J. Soulen. 1932.*

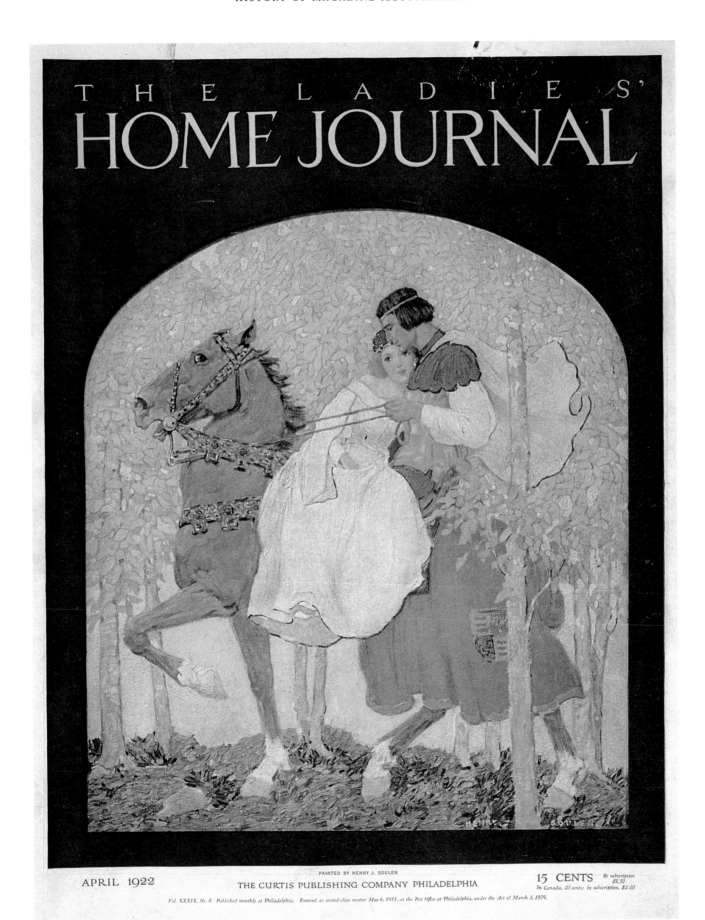

The Ladies' Home Journal. *Henry J. Soulen. 1922.*

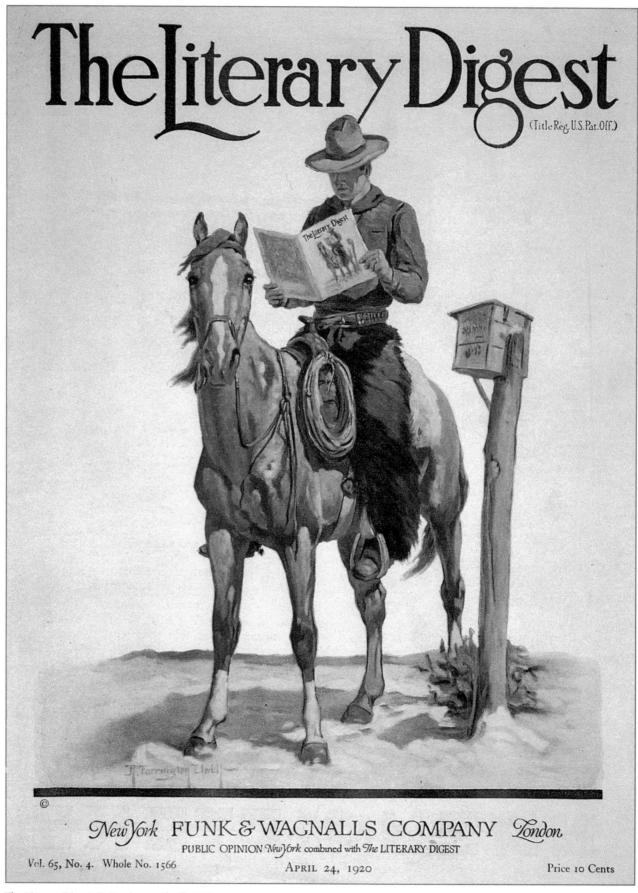

The Literary Digest. *R. Farrington Elwell. 1920.*

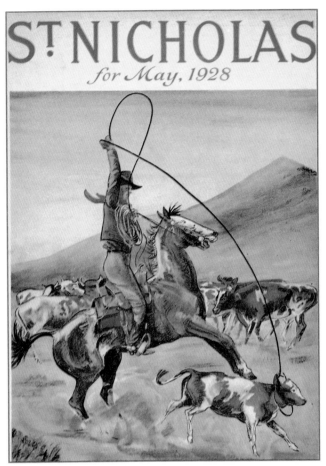

St. Nicholas. *1928.*

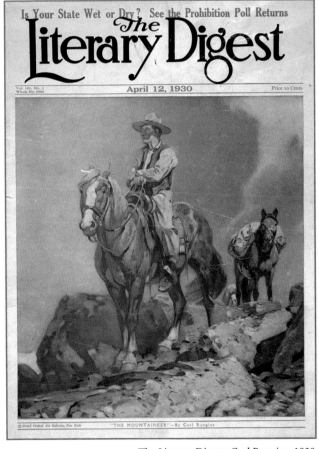

The Literary Digest. *Carl Rungius. 1930.*

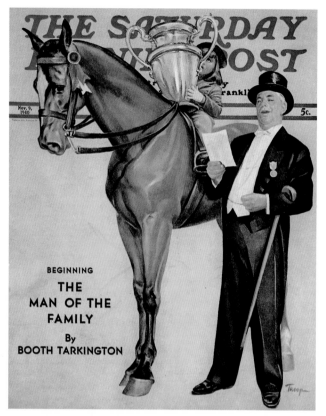

The Saturday Evening Post. *Troop. 1940.*

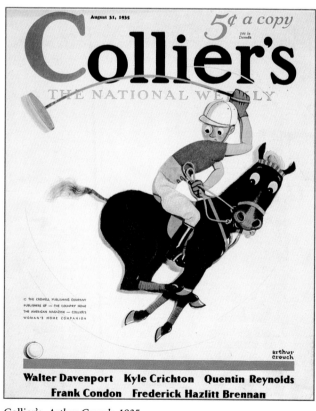

Collier's. *Arthur Crouch. 1935.*

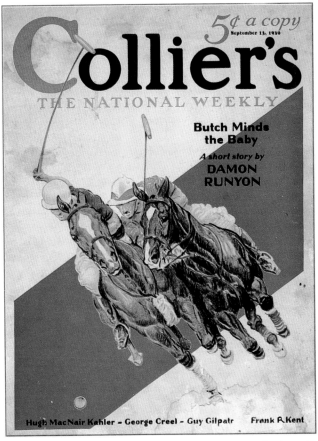

Collier's. *1930.*

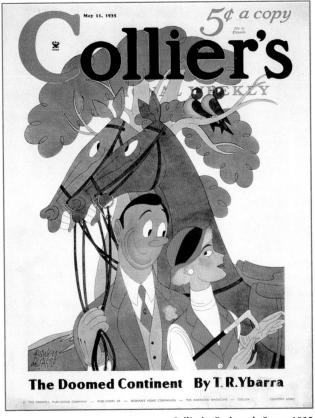

Collier's. *Rodney de Sarro. 1935.*

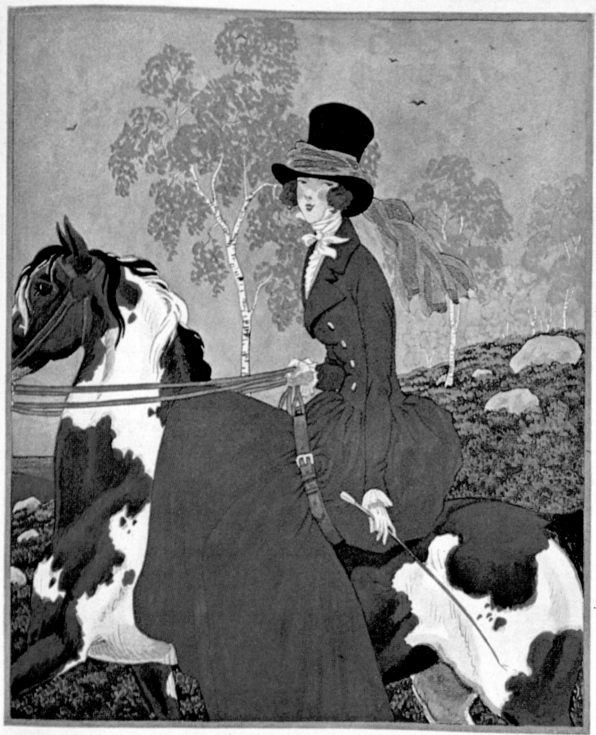

Vogue. *Pierre Brissaud. 1927.*

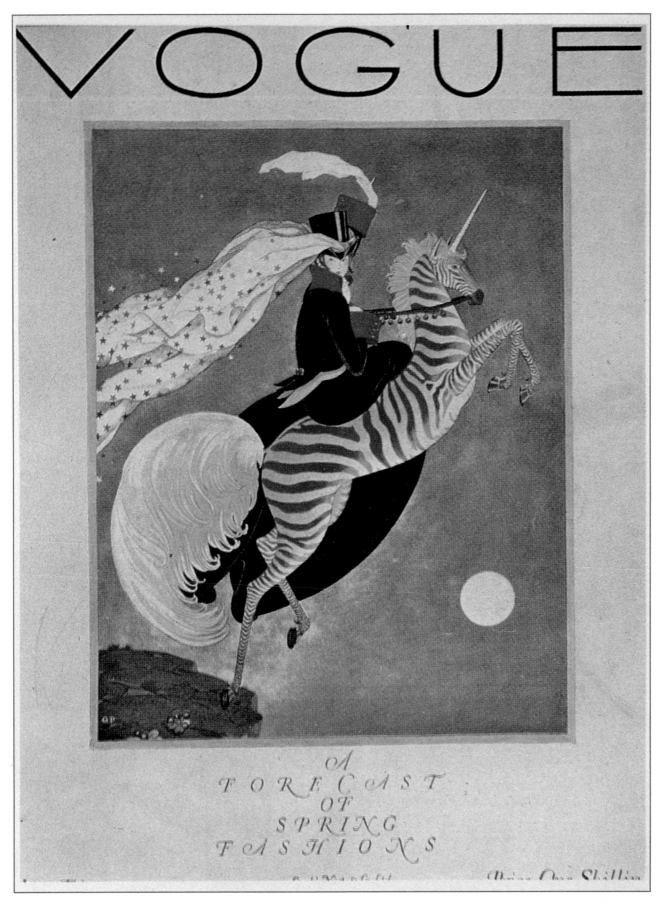

Vogue. *George Plank. 1927.*

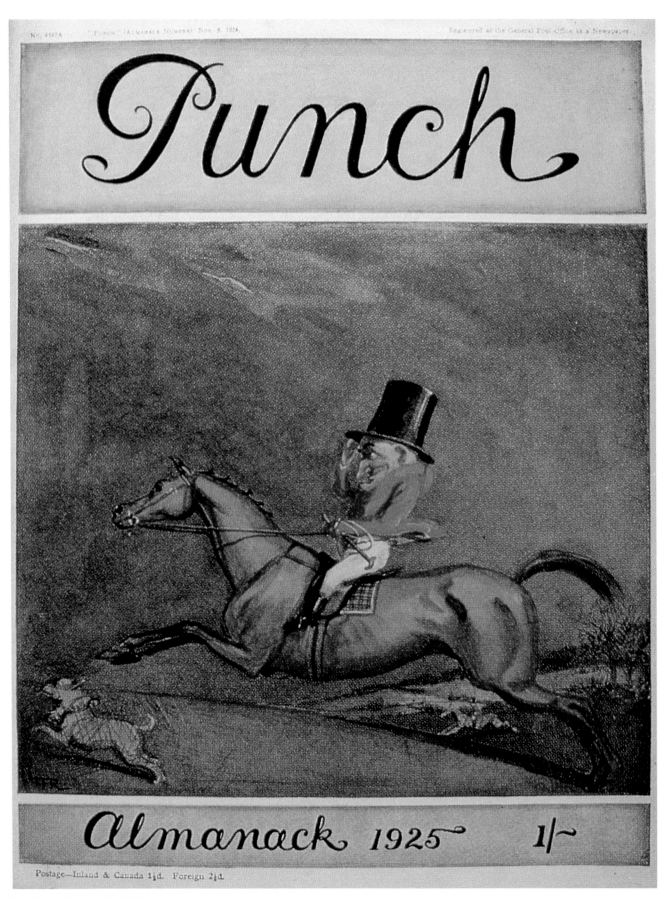

Punch. *Frank Reynolds. 1925.*

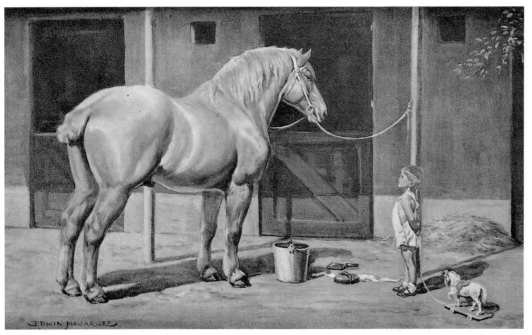

A Belgian. The Country Home. *Edwin Megargee. 1935.*

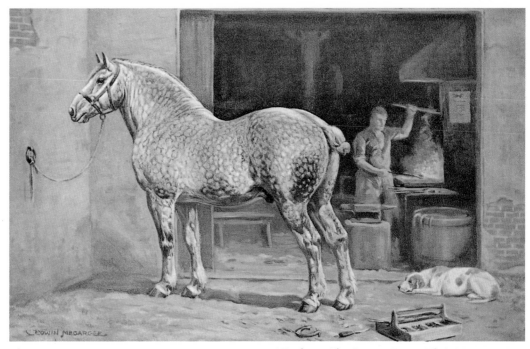

A Percheron. The Country Home. *Edwin Megargee. 1935.*

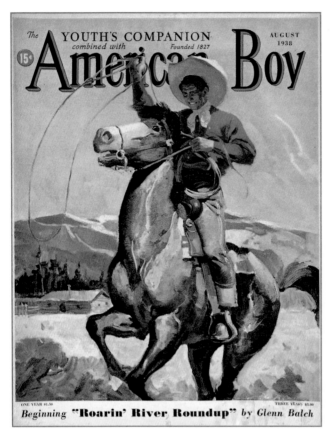

American Boy. *1938.*

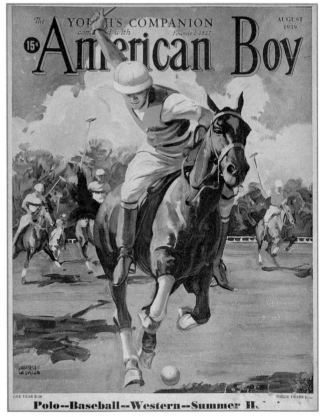

American Boy. *Charles La Salle. 1939.*

The March
1929
American Boy

African Adventure—"The Builder of the Dam," by William Heyliger

Price 20 Cents

$2.00 a Year

American Boy. *Albin Henning. 1929.*

Printed in Italy by the E.N.I.T. 1938-XVII

Italia. *1938.*

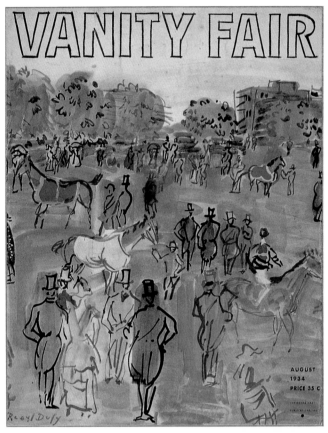

Vanity Fair. *Raoul Dufy. 1934.*

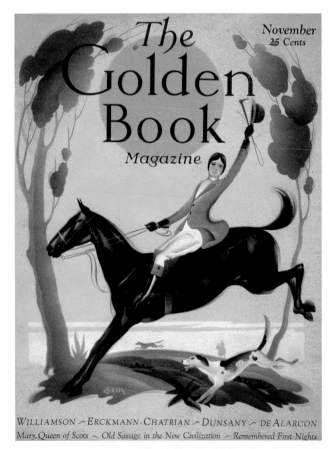

The Golden Book Magazine. *Leech. 1930.*

McCall's Style and Beauty. *1933.*

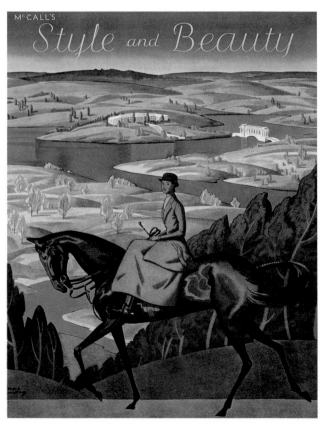

McCall's Style and Beauty. *Edwin A. Wilson. 1943.*

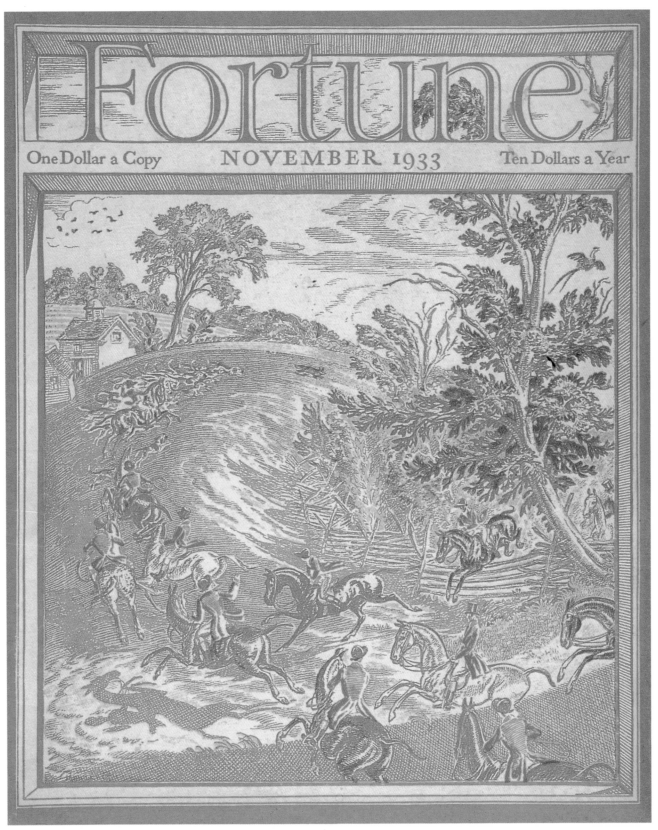

Fortune. *1933.*

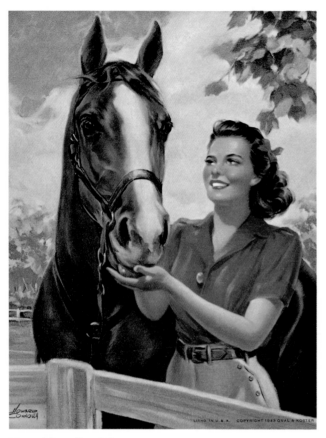

Howard Connolly. 1943.

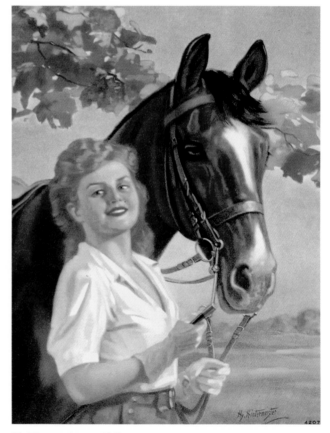

Hy Hintermeister. c.1940.

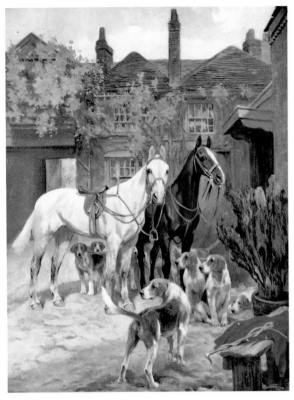

Waiting for the Start. c.1940.

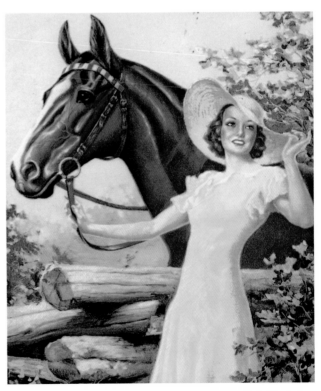

A Pair of Beauties. c.1940.

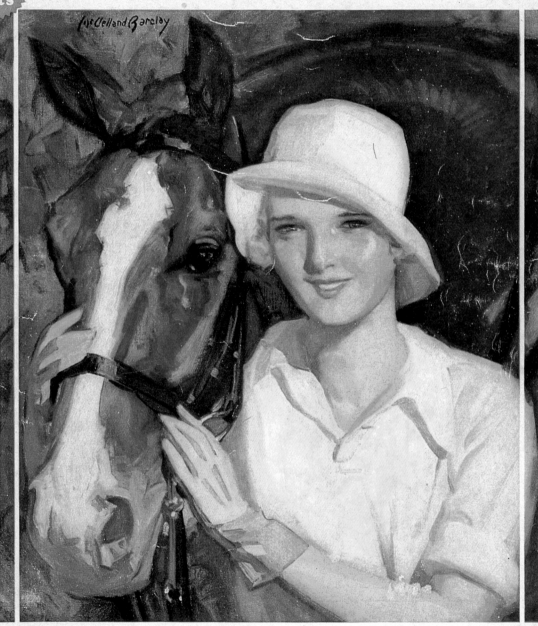

Pictorial Review. *McClelland Barclay. 1930.*

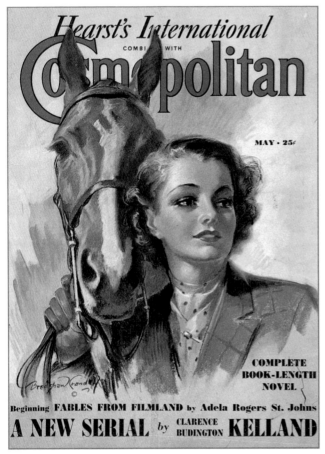

Hearst's International Cosmopolitan. *Bradshaw Crandall. 1937.*

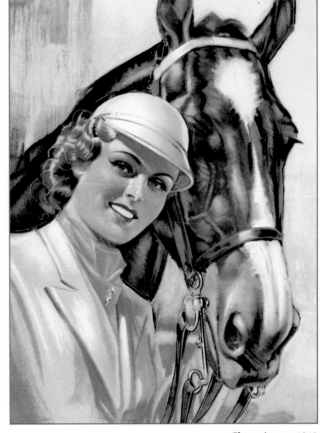

Champions. *c.1940.*

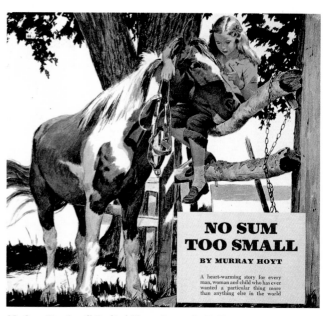

No Sum Too Small. Ladies' Home Journal. *1947.*

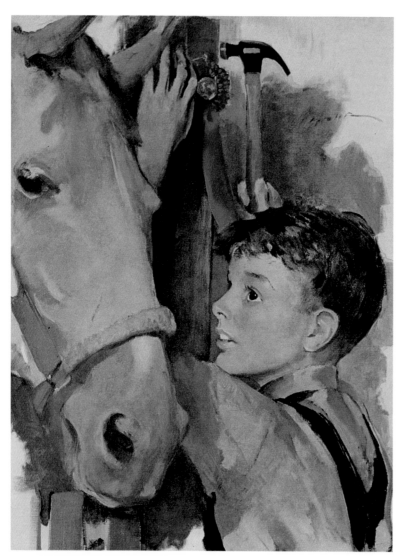

Peter tacked the blue ribbon beside Gray Boy's stall. It was, said Peter, Gray Boy's ribbon. He had won it. Ladies' Home Journal. *Roy Spreter. 1937.*

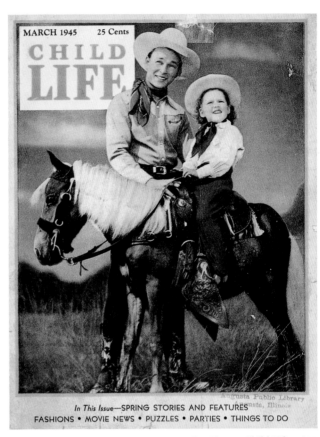

Roy Rogers. Child Life. *1945.*

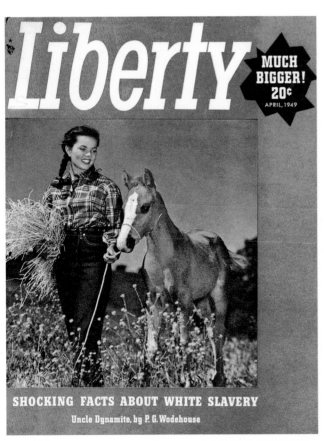

Liberty. *1949.*

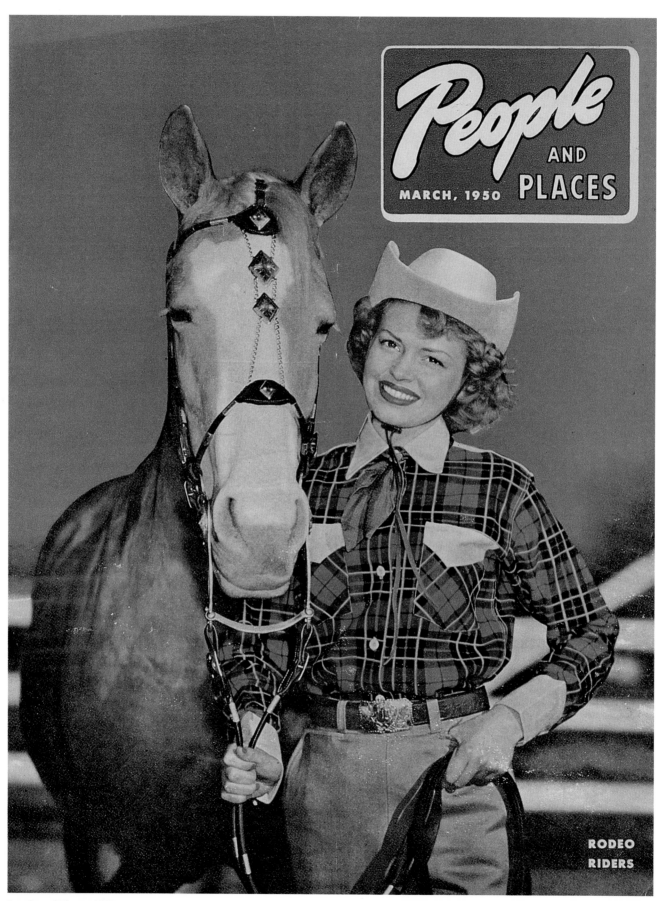

People and Places. *1950.*

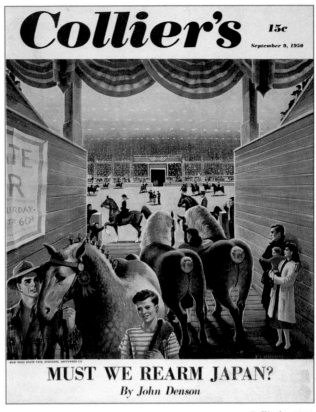

Collier's. *1950.*

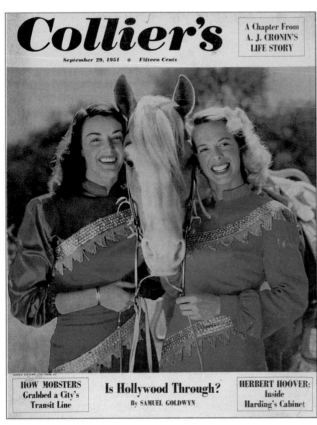

Collier's. *1951.*

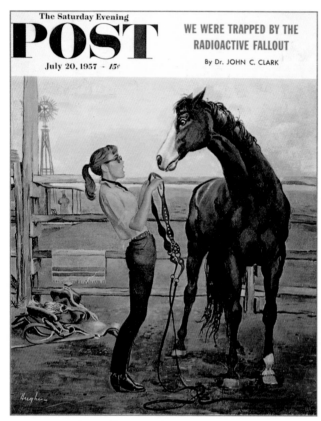

The Saturday Evening Post. *Hughes. 1957.*

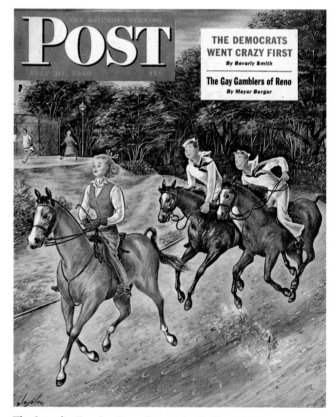

The Saturday Evening Post. *Constantin Alajálov. 1948.*

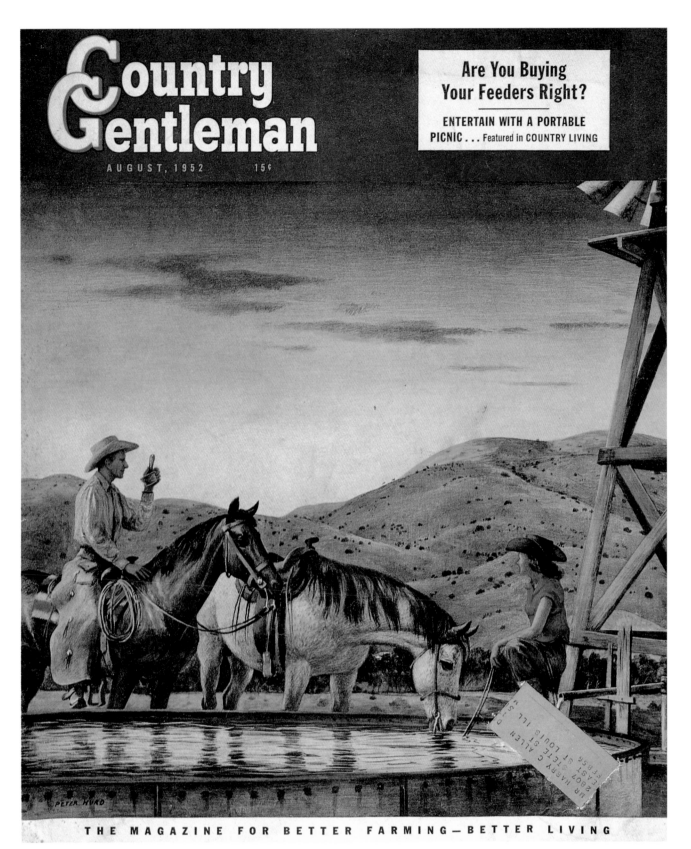

Country Gentleman. *Peter Hurd. 1952.*

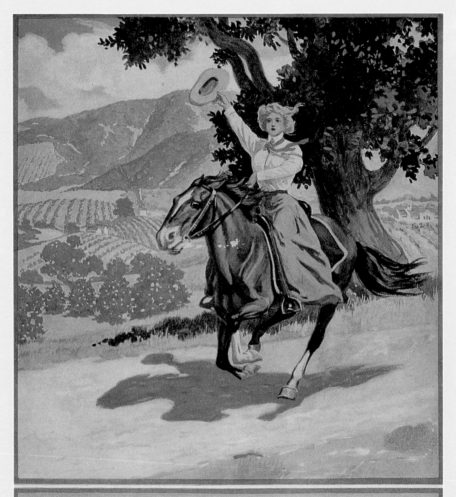

Southern Pacific. 1909.

"Advertising is now so near to perfection that it is not easy to propose any improvement."

Samuel Johnson, 1759

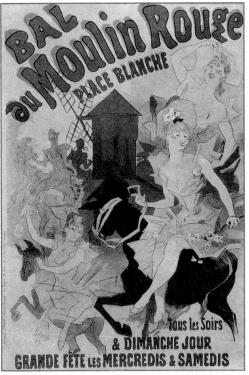

Bal du Moulin Rouge. 1889.

*I*n spite of Dr. Johnson's prophesy more than two centuries ago, advertising has indeed seen vast changes and improvements. It has evolved into a major part of our culture today, with worldwide advertisers spending over $240 billion a year to promote and sell their goods and services.

Advertising, destined to be the omnipresent, most characteristic and most remunerative form of American literature, did not come into its own until the second half of the nineteenth century.

Prior to the U.S. Civil War, with the factory system still in its infancy, agriculture was the dominant source of national wealth. The market for the products of these early manufacturing and agricultural enterprises was generally the people living in the village, town or city immediately surrounding the producing center.

A fledgling distribution network existed to carry these products to other markets (there were more than 30,000 rail miles in the U.S. in 1860), but there was little demand for its use other than for agricultural products. At this early stage in American manufacturing, sophisticated distribution of goods was not yet developed.

In a selling environment, where producers were assured of a larger market than their production capacities could meet, it is not surprising to find that most manufacturers did not attempt to differentiate their own products from similar goods. Their products usually carried no identifying brands or marks, and they were normally sold by local retailers from bulk lots, along with the products of other producers.

With the majority of producers enjoying an assured market, the small amount of advertising undertaken during this pre-war period was placed by retailers attempting to reach customers in their immediate geographic areas. The medium for carrying these factual-only notices was the local newspaper. Aside from printed notices and posters, this was the only practical choice available.

The U.S. Civil War accelerated a national trend toward industrialization, and for the first time there was some tentative use of

advertising beyond the retail level. With the completion of the transcontinental railroad, the continental age of advertising had truly begun.

At the outset of the 1880s manufacturers were blessed by blossoming sales. They had just emerged from a decade that had seen the invention of the telephone, the incandescent lamp and significant innovations in factory products. In 1880 alone there were applications for more than 13,000 copyrights and patents, giving rise to an ever-increasing stream of new products from mills and factories.

The potential consumer markets for these goods were also increasing at a dramatic rate, expanding with the transportation capabilities provided by thousands of miles of railroads and roads throughout the ever-enlarging American nation.

In order to achieve effective distribution of their products, manufacturers needed an advertising medium that could reach all sections of their expanded market area. Such a medium was the national magazine, transported by the railroad lines into the American towns, where store shelves carried branded products brought by the same rails.

The increasingly popular tool of advertising in magazines led to some spectacular sales successes by its regular users. This success led to a further increase in advertising, which in turn helped lower the public price of each magazine and, as a result, boosted circulation. Advertisers pumped large sums of money into the industry, as they discovered that the buying power of the rising middle class could best be tapped through magazines. Thus, advertising was inextricably tied to the growth of newspapers, magazines and increased consumerism.

Advertising also changed the entire concept of magazine publishing. Up to this time publishers had generally relied on the readers themselves to pay for the cost of the magazines through the newsstand and subscription prices. But as advertising revenues continued to reward the confidence of advertisers in the medium's ability to deliver a selling message economically, this concept changed. Thus, in 1890 a publisher was quoted as saying, "If I can get a circulation of 400,000, I can afford to give my magazine away to anyone who'll pay the postage." The publisher was no longer simply creating a medium of entertainment, but rather a profitable advertising vehicle that would reach a certain number of potential customers to fully fund his magazine.

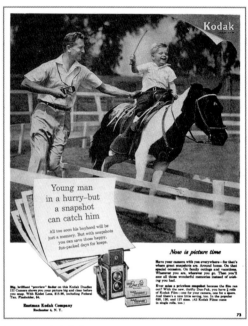

Eastman Kodak Company. 1954.

As advanced technology permitted low-cost reproduction of illustrations and color lithography, advertisers became increasingly competitive in their creativity. This led to new found uses of graphics in advertising, in order to give the reader a visual image of the product or to evoke a positive feeling towards the product.

It is not difficult to understand why the English Prime Minister, William Gladstone, insisted on sending to America for magazines, even when English editions were available. It was the American advertisements that fascinated him.

During this period, horsemanship was associated with a life of leisure, manners and good taste. Advertisers of many products incorporated these lifestyle images into their product messages through the use of illustrations depicting horses. The visual associations consumers made when seeing equestrian graphics created increased interest in horsemanship itself. As the public was hungrily trying new consumer products, they were equally anxious to learn of the exciting and challenging new recreational activities and competitions rapidly spreading around the world.

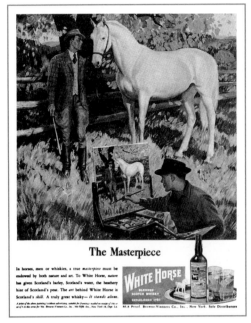

Browne-Vintners Co., Inc. 1947.

During the 1920s and 1930s advertising art came into its own as never before. Greater freedom and larger budgets allowed outstanding artists to use horses to enrich the appeal of many useful objects. Manufacturers hired some of the best illustrators and artists to create the visual messages they desired.

The illustrations that follow in this volume are wonderful examples of the graphic advances used in advertising during riding's popular growth years. They invite us to enter a world where we can take to the hunt with Pfaff's Lager, flash across the fields with great speed after drinking a fine scotch whiskey, or show off our finest tailored clothes while wearing a gentlemanly scent of cologne. At the same time they allow us to appreciate how colorful and evocative such a world might be.

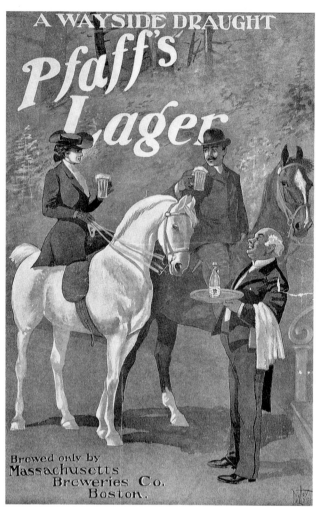

Massachusetts Breweries Co. 1905.

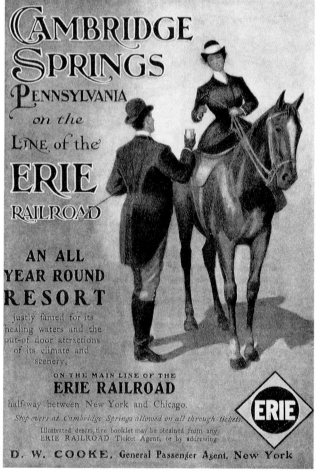

Erie Railroad. 1905.

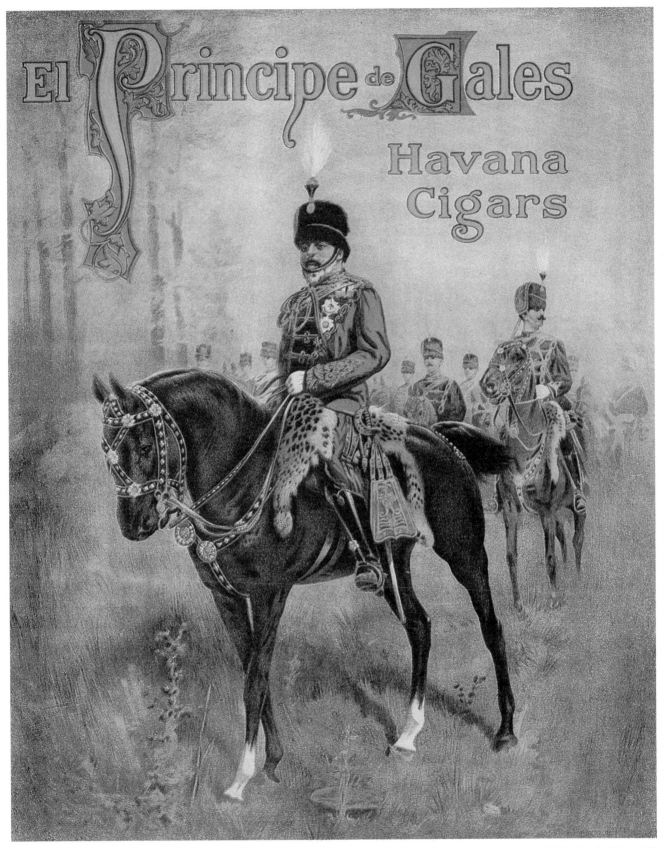

El Principe de Gales. 1912.

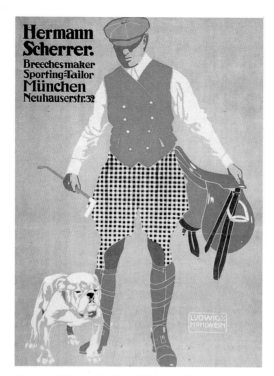

Hermann Scherrer. Ludwig Hohlwein. 1911.

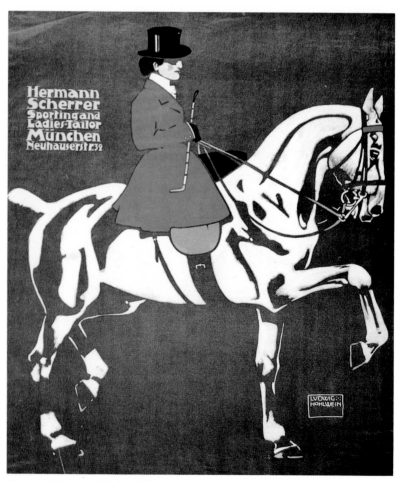

Hermann Scherrer. Ludwig Hohlwein. 1908.

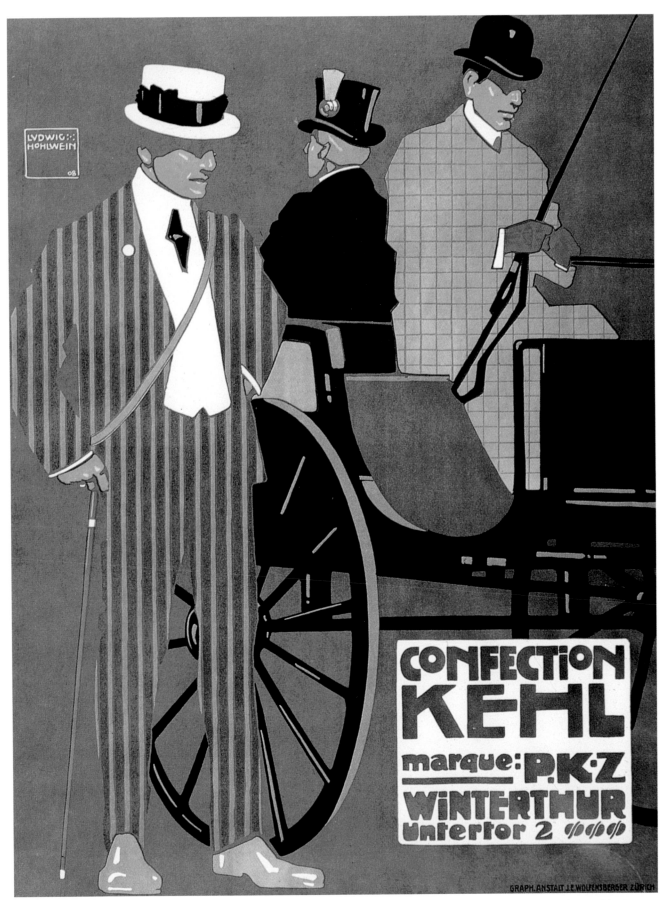

Confection Kehl. Ludwig Hohlwein. 1908.

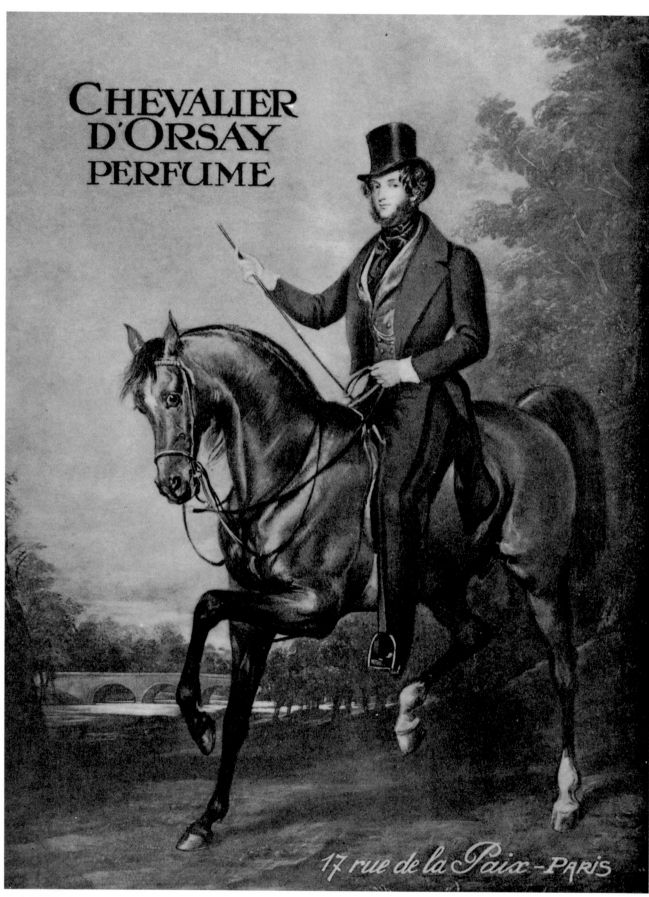

Chevalier D'Orsay. c.1920.

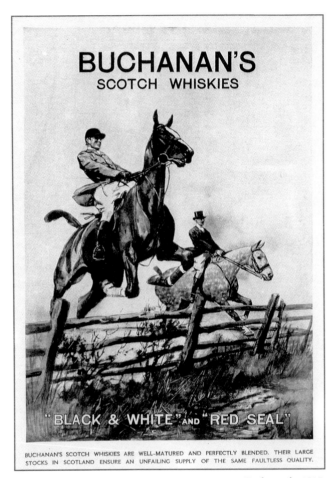

Buchanan's. 1915.

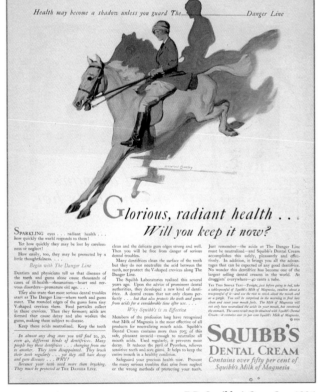

E.R. Squibb & Sons, Inc. 1926.

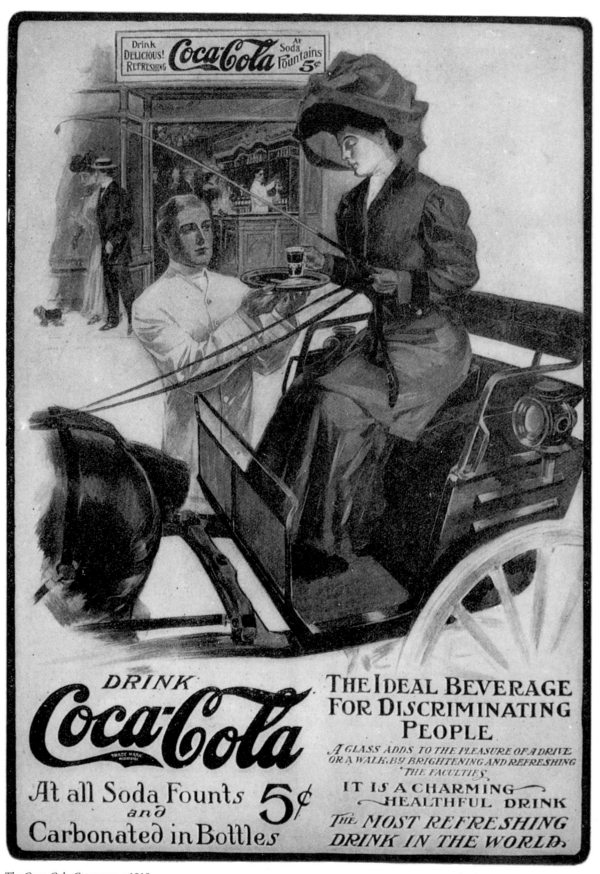

The Coca-Cola Company. c.1910.

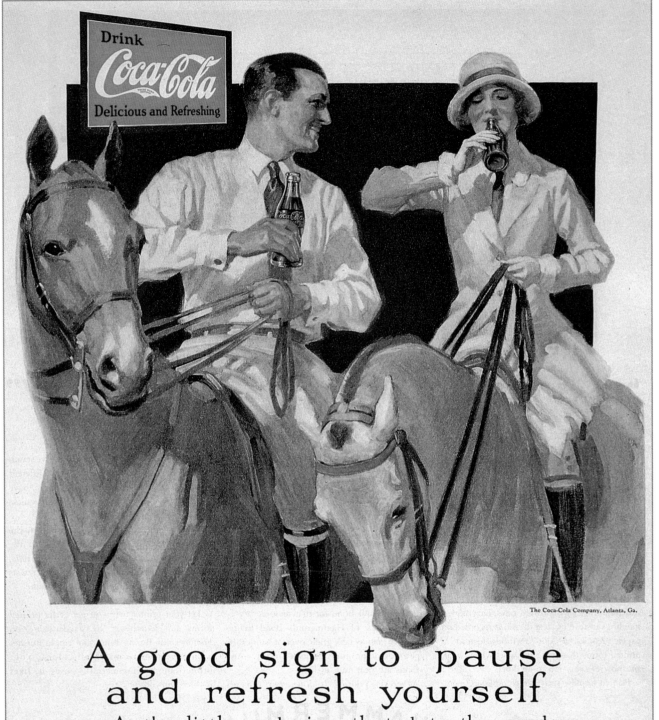

The Coca-Cola Company, Atlanta, Ga.

A good sign to pause and refresh yourself

At the little red sign that dots the road map of the world, over 7 million a day stop to enjoy Coca-Cola ~ the drink with that taste-good feeling and delightful after-sense of refreshment.

IT HAD TO BE GOOD TO GET WHERE IT IS

The Coca-Cola Company. 1927.

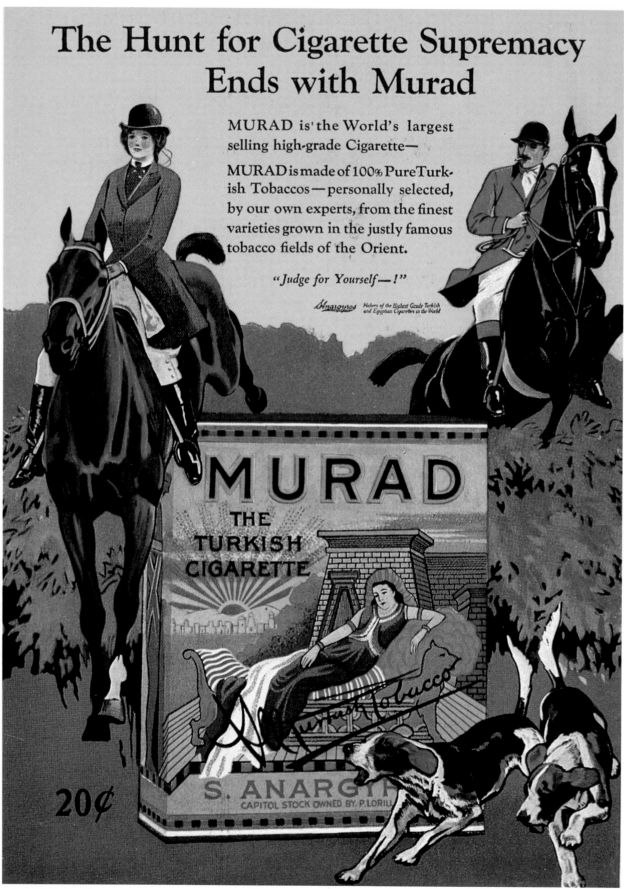

P. Lorillard Co. c.1925.

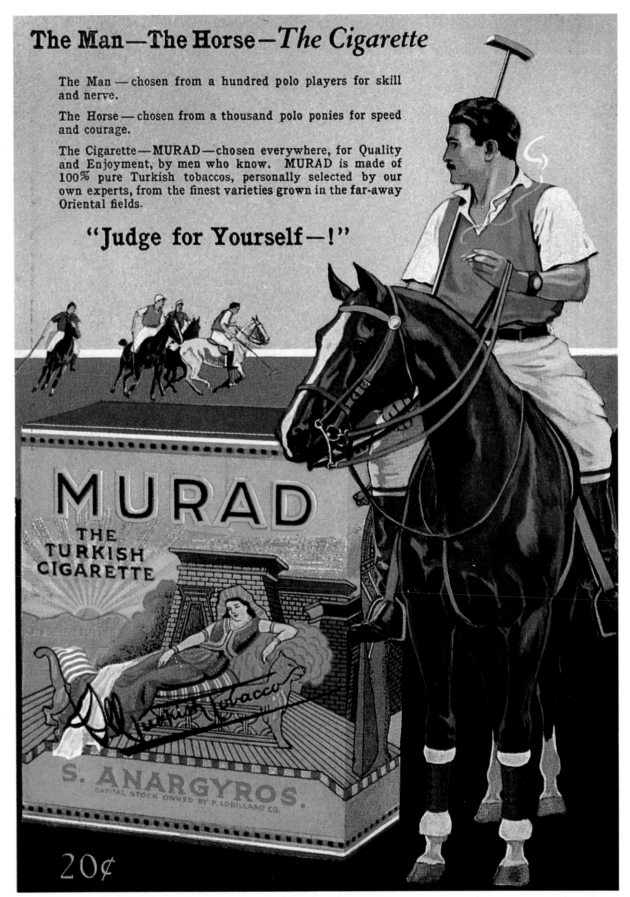

The Man—The Horse—*The Cigarette*

The Man — chosen from a hundred polo players for skill and nerve.

The Horse — chosen from a thousand polo ponies for speed and courage.

The Cigarette—MURAD—chosen everywhere, for Quality and Enjoyment, by men who know. MURAD is made of 100% pure Turkish tobaccos, personally selected by our own experts, from the finest varieties grown in the far-away Oriental fields.

"Judge for Yourself—!"

MURAD
THE TURKISH CIGARETTE

S. ANARGYROS.
CAPITAL STOCK OWNED BY P. LORILLARD CO.

20¢

P. Lorillard Co. c.1925.

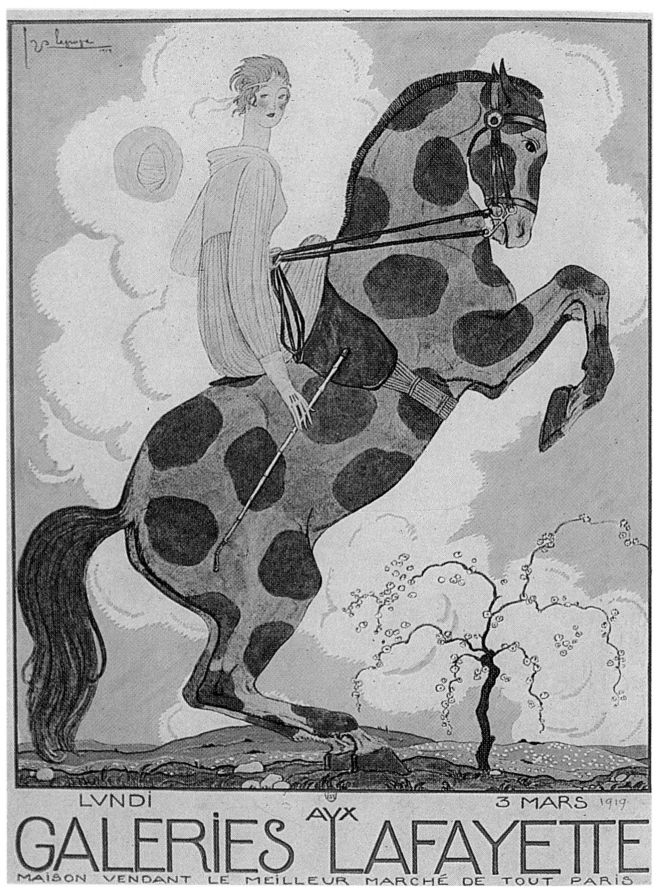

Galeries Lafayette. Georges Lepape. 1919.

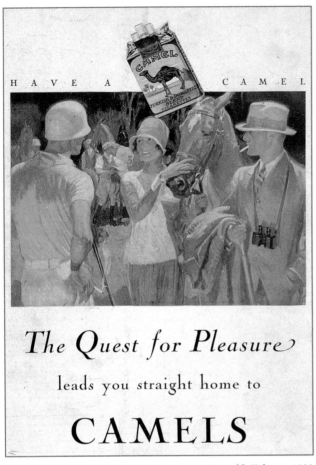

R.J. Reynolds Tobacco. 1928.

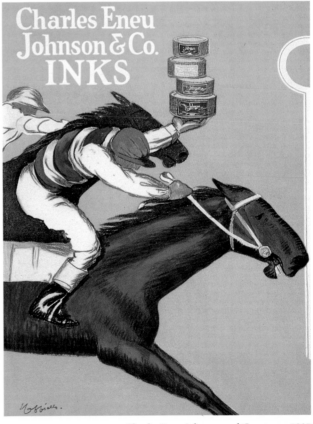

Charles Eneu Johnson and Company. 1927.

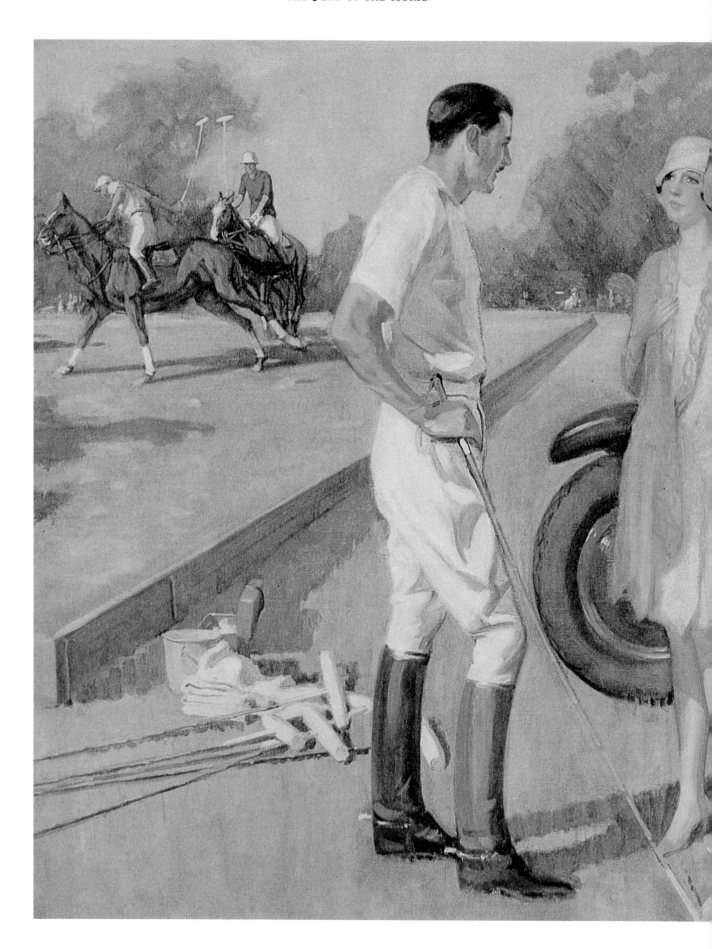

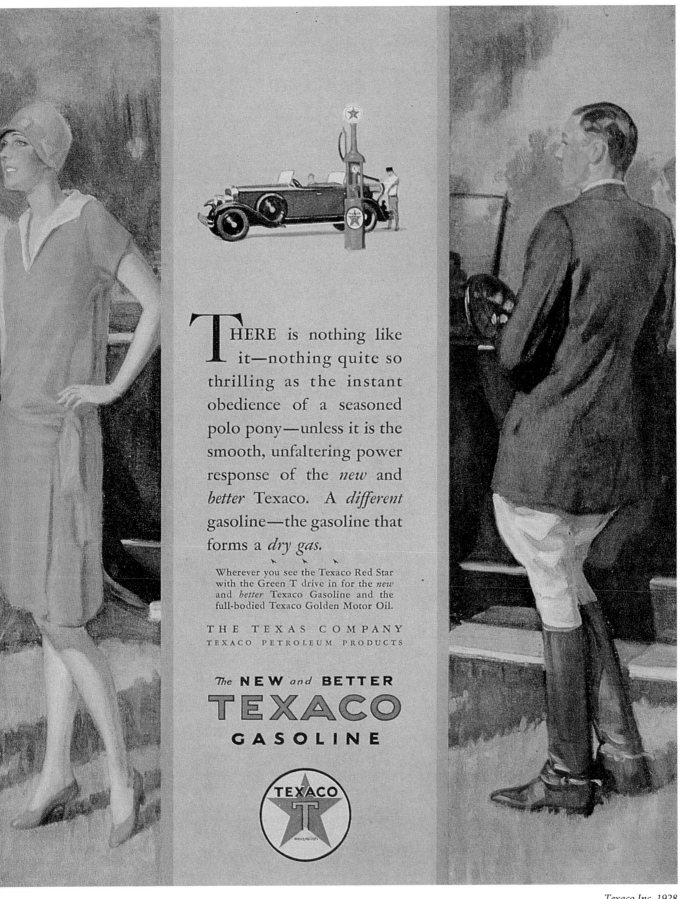

THERE is nothing like it—nothing quite so thrilling as the instant obedience of a seasoned polo pony—unless it is the smooth, unfaltering power response of the *new* and *better* Texaco. A *different* gasoline—the gasoline that forms a *dry gas.*

Wherever you see the Texaco Red Star with the Green T drive in for the *new* and *better* Texaco Gasoline and the full-bodied Texaco Golden Motor Oil.

THE TEXAS COMPANY
TEXACO PETROLEUM PRODUCTS

The NEW *and* BETTER
TEXACO
GASOLINE

Texaco Inc. 1928.

say "ARROW," *then say* "SANFORIZED=SHRUNK" *don't take* "NO" *or else* invite

confusion . . . and get less than a GUARANTEE OF PERMANENT FIT

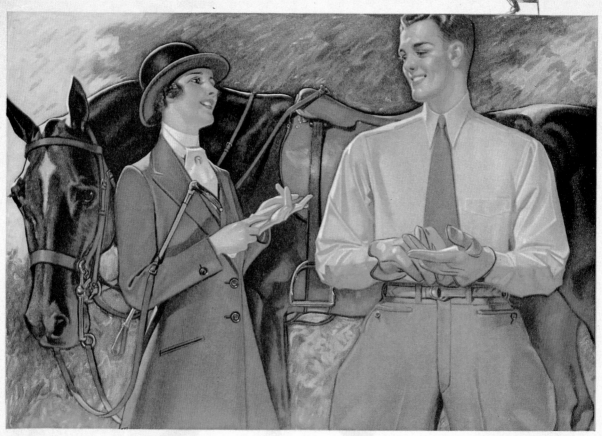

Arrow's new spring Broadcloths are ready!

YOU will save style-shopping by aiming straight for any Arrow shop to pick out *your* style in *your* colors and *your* exact marked size—at *your* price. You will save untold confusion about shrinkage by saying—right out loud —"I want Arrow Sanforized-Shrunk Shirts," for with every one you are guaranteed permanent fit. Please put Arrow to the test: if the collar binds after *any* washing, if the sleeves "climb," or the body-length shortens out-of-fit, you will get your money back at once. You guarantee yourself the absolute style of Arrow's fine broad-

cloth, the perfect fit of Arrow's collar on the shirt. The following Arrow broadcloths (with genuine Arrow Collars) are Sanforized-Shrunk (guaranteed by Arrow for permanent fit): Trump, in white and in colors at $1.95; Paddock, in white and colors at $2.50; Mayfair, in white and colors at $3; Claridge, in white and colors at $3.50; Baronet, in white and colors at $5 — the differences being only the relative fineness of the lustrous fabric itself.

CLUETT, PEABODY & CO., INC., TROY, N. Y.

Your favorite shop now has the *new* Arrow Broadcloth shirts for Spring. Colors are blue, tan and green (shown here) also *Silver Grey, Apricot, Peach, Corn and Havana Brown*. All guaranteed fast colors, of course.

ARROW SANFORIZED SHRUNK SHIRTS

Cluett, Peabody and Company. 1931.

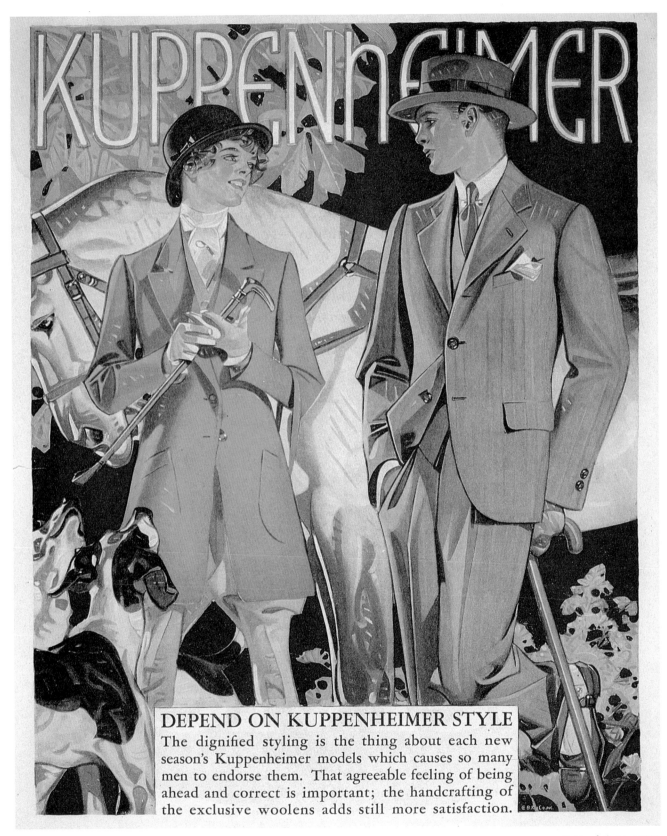

DEPEND ON KUPPENHEIMER STYLE
The dignified styling is the thing about each new season's Kuppenheimer models which causes so many men to endorse them. That agreeable feeling of being ahead and correct is important; the handcrafting of the exclusive woolens adds still more satisfaction.

Kuppenheimer. c.1928.

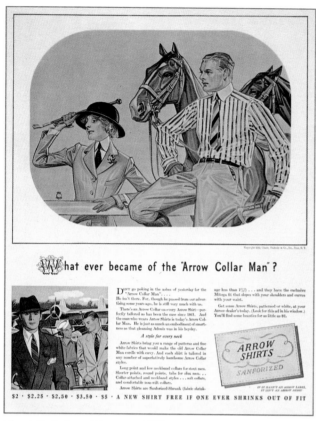

Cluett, Peabody and Company. 1939.

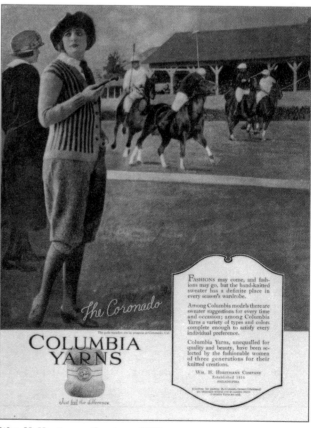

Wm. H. Horstmann Company. 1923.

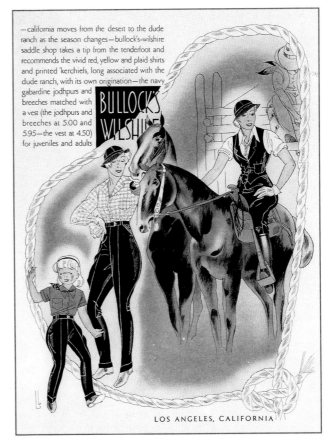

Bullock's Wilshire. 1934.

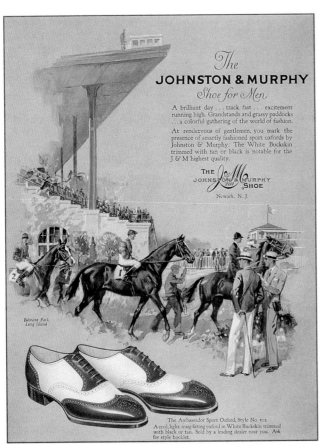

The Johnston & Murray Shoe Co. 1928.

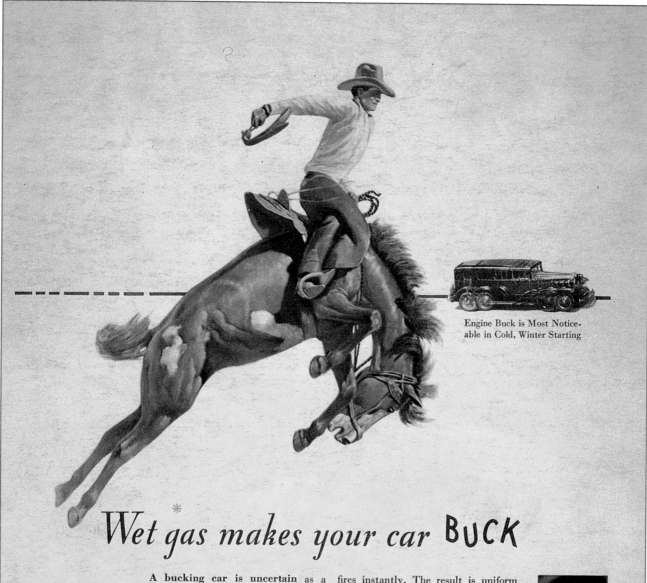

Engine Buck is Most Notice-
able in Cold, Winter Starting

Wet gas makes your car BUCK

Reproduction from a painting by Will James

*

Dry gas vaporizes completely because it is properly refined. *Wet* gas vaporizes only in part. *Wet* gas carries an uneven spray of raw wet gasoline which chokes some cylinders at the expense of others, causes crankcase dilution and wasted power. *Dry* gas goes through the manifold evenly. It burns completely, delivering all its power into every cylinder.

A bucking car is uncertain as a bronco fresh from the plains. Bucking is often caused by wet gas which flows unevenly to the cylinders, especially on cold winter days. Some cylinders flash into power and others fail to fire. It is hard on any car.

Texaco-Ethyl, the dry* Ethyl gasoline, helps eliminate the tendency to engine buck. It enters the cylinders completely vaporized—a dry* gas which

fires instantly. The result is uniform power which assures even pick-up, gliding acceleration and smooth engine pull at every speed.

You can always get this matchless dry-gas power at any silver Texaco pump. Use it in your own car. Texaco-Ethyl is the only Ethyl gasoline sold in all our 48 States.

THE TEXAS COMPANY
Refiners of a complete line of Texaco Petroleum Products, including Gasoline, Motor Oil, Industrial, Railroad, Marine and Farm Lubricants, Road Asphalts and Asphalt Roofing

use dry

TEXACO-ETHYL
ELIMINATES ENGINE BUCK

© 1931, The Texas Company

Texaco Inc. 1931.

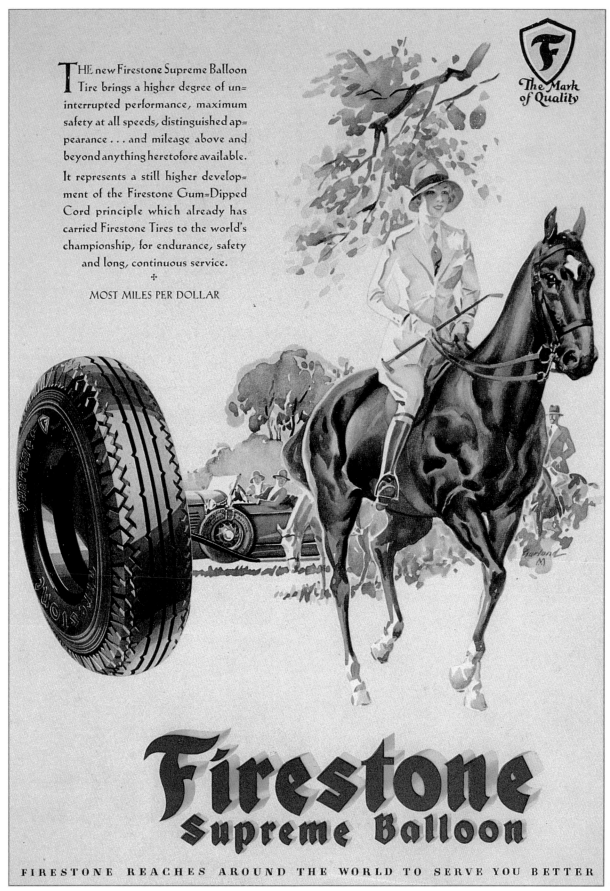

THE new Firestone Supreme Balloon Tire brings a higher degree of un=interrupted performance, maximum safety at all speeds, distinguished ap=pearance . . . and mileage above and beyond anything heretofore available.

It represents a still higher develop=ment of the Firestone Gum=Dipped Cord principle which already has carried Firestone Tires to the world's championship, for endurance, safety and long, continuous service.

✦

MOST MILES PER DOLLAR

The Mark of Quality

Firestone
Supreme Balloon

FIRESTONE REACHES AROUND THE WORLD TO SERVE YOU BETTER

The Firestone Tire & Rubber Co. 1929.

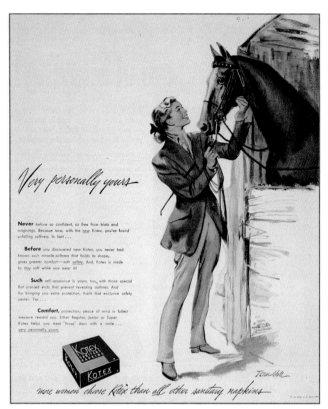

Kimberly-Clark Corporation. 1948.

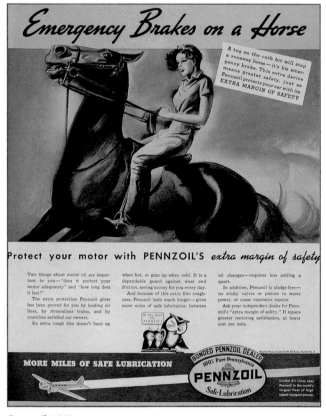

Pennzoil. 1937.

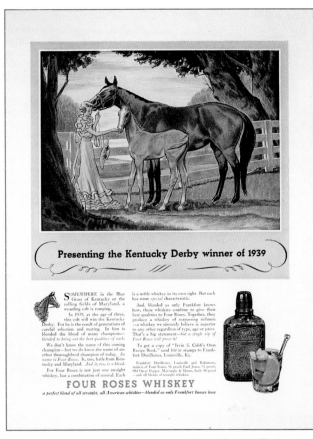

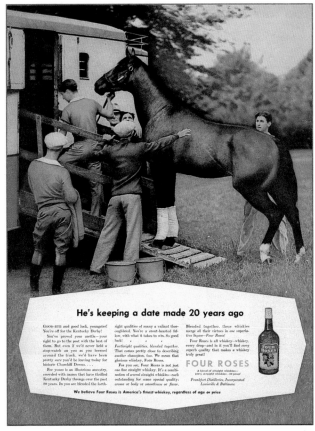

Frankfort Distilleries. 1936.

Frankfort Distilleries. 1938.

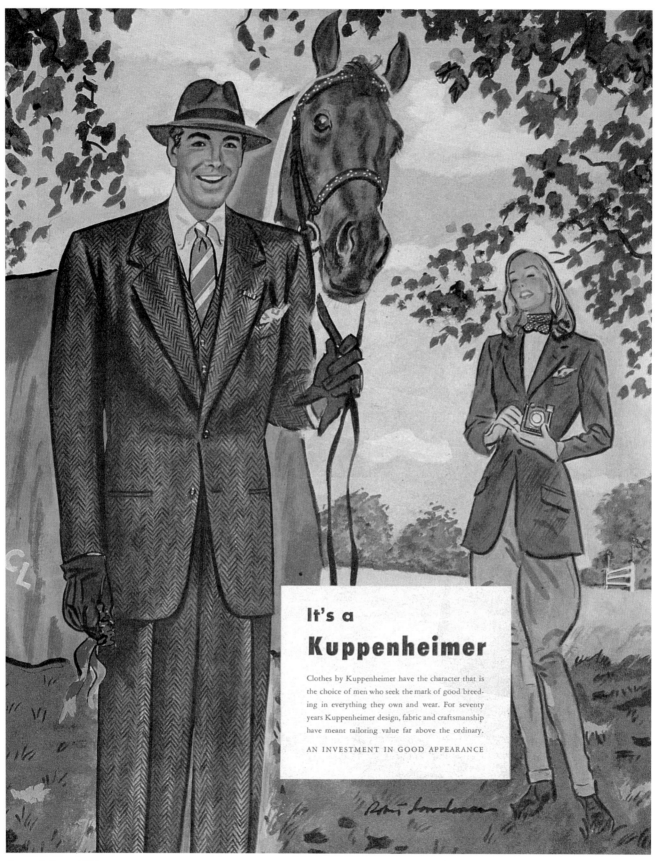

It's a
Kuppenheimer

Clothes by Kuppenheimer have the character that is the choice of men who seek the mark of good breeding in everything they own and wear. For seventy years Kuppenheimer design, fabric and craftsmanship have meant tailoring value far above the ordinary.

AN INVESTMENT IN GOOD APPEARANCE

Kuppenheimer. 1946.

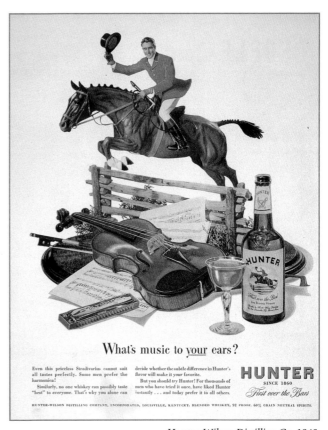

Hunter-Wilson Distilling Co. 1948.

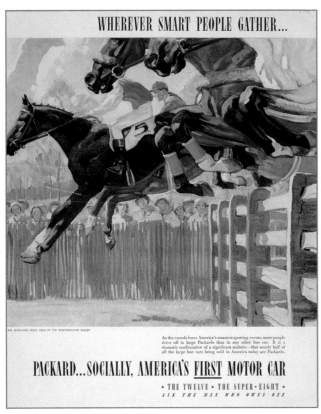

Packard. c.1940.

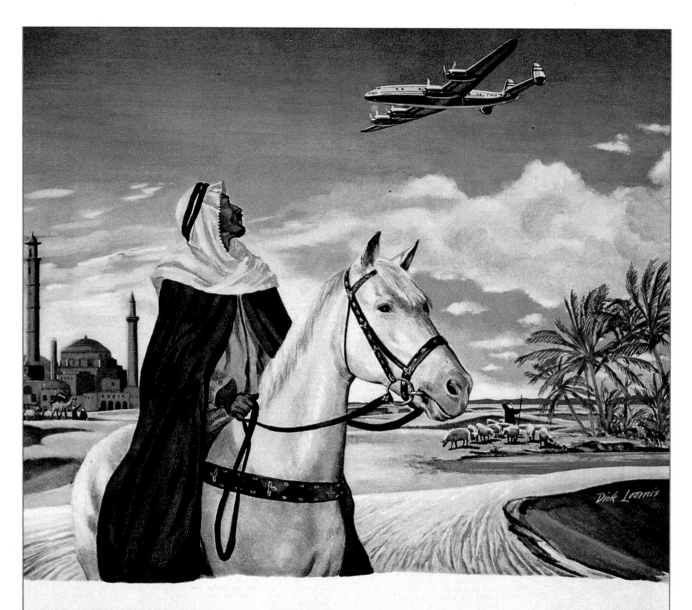

MAGIC CARPET TO ARABIA

✠ *Gently the broad wings of your TWA Starliner ease you down over this land of majestic mosques and slender minarets—of date-laden oases and spirited Arabian steeds. By this modern magic carpet it is less than two days to Arabian nights. And they are days made exciting by a swift air panorama of many foreign lands —days made pleasant by airmanship born of experience in trans world flying at the rate of 5 million miles a month. At home or abroad, flying is the way to travel these days, and TWA is the way to fly. And your travel agent or your nearest TWA office can arrange such magic-carpet trips from your home to almost anywhere.*

Direct
one-carrier
service to
ALGERIA
BURMA
CEYLON
CHINA
EGYPT
FRANCE
GREECE
INDIA
INDO-CHINA
IRAQ
IRELAND
ITALY
LIBYA
NEWFOUNDLAND
OMAN
PALESTINE
PORTUGAL
SAUDI ARABIA
SPAIN
SWITZERLAND
TRANS-JORDAN
TUNISIA

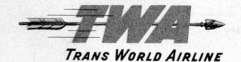

TWA
TRANS WORLD AIRLINE

Trans World Airline. 1946.

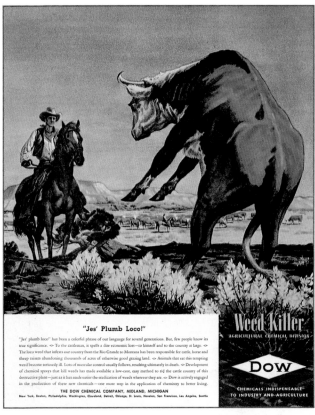

The Dow Chemical Company. 1946.

General Foods. 1946.

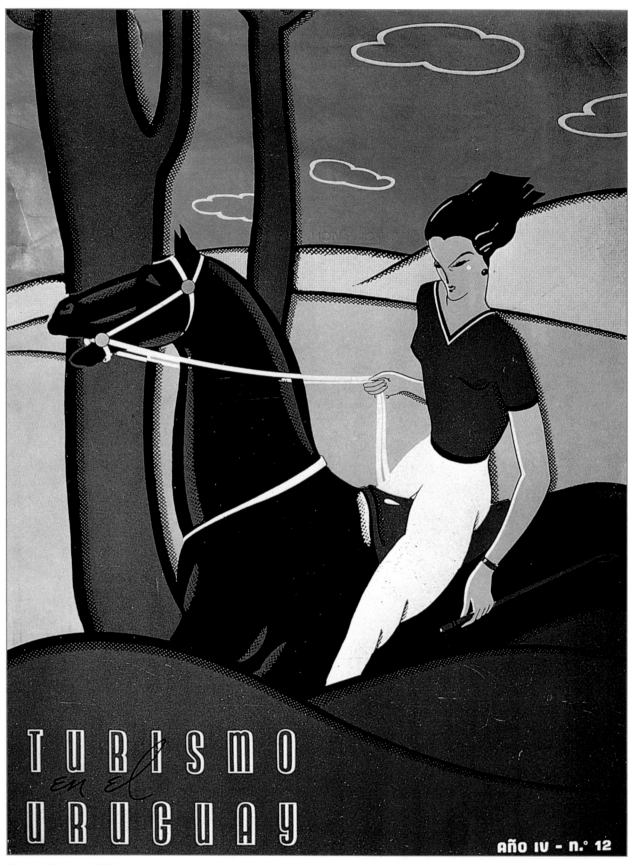

Turismo Uruguay. 1938.

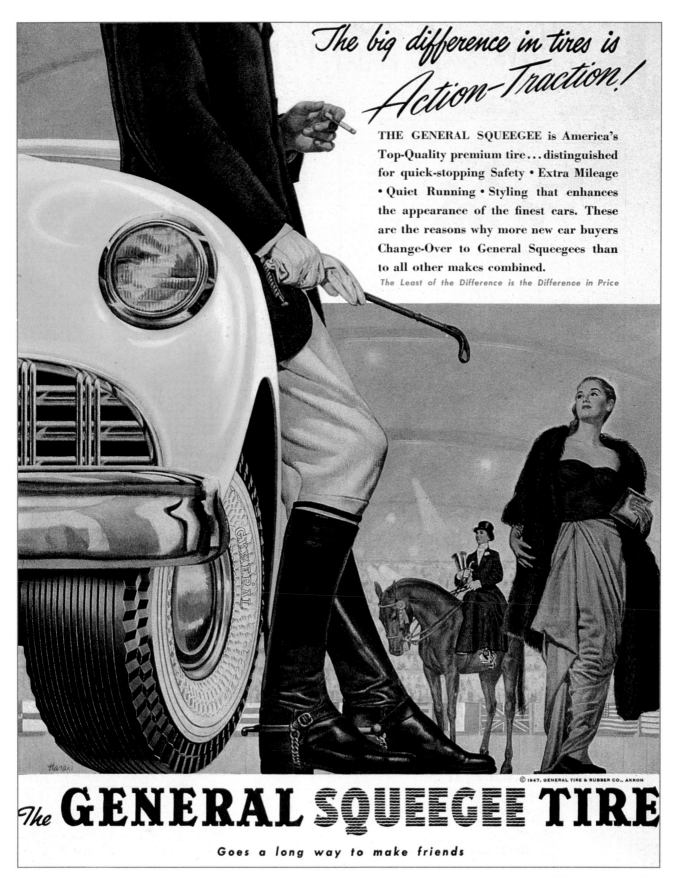

The big difference in tires is *Action-Traction!*

THE GENERAL SQUEEGEE is America's Top-Quality premium tire...distinguished for quick-stopping Safety • Extra Mileage • Quiet Running • Styling that enhances the appearance of the finest cars. These are the reasons why more new car buyers Change-Over to General Squeegees than to all other makes combined.

The Least of the Difference is the Difference in Price

© 1947, GENERAL TIRE & RUBBER CO., AKRON

The **GENERAL SQUEEGEE TIRE**

Goes a long way to make friends

General Tire & Rubber Co. 1947.

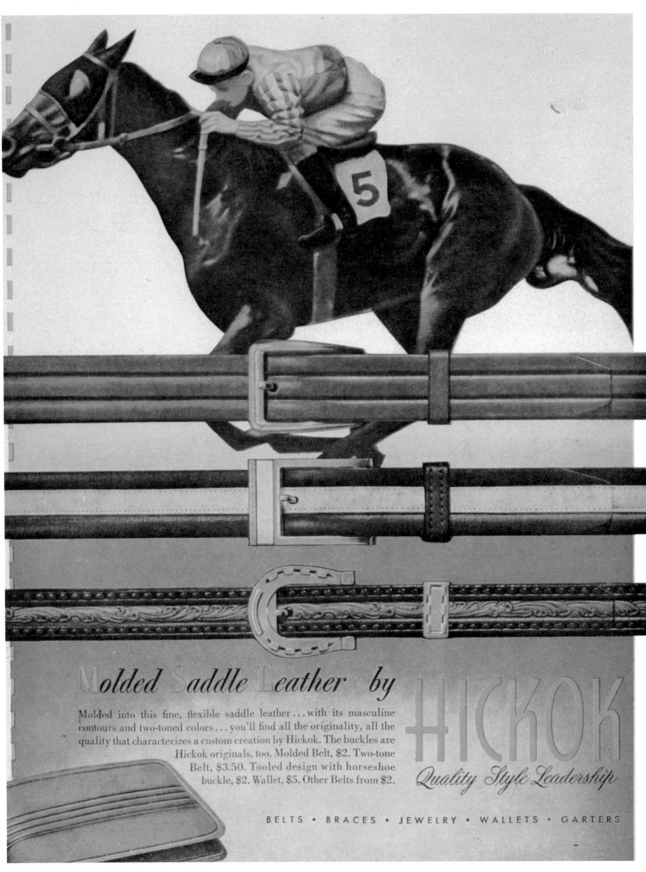

Molded Saddle Leather by HICKOK

Molded into this fine, flexible saddle leather...with its masculine contours and two-toned colors...you'll find all the originality, all the quality that characterizes a custom creation by Hickok. The buckles are Hickok originals, too. Molded Belt, $2. Two-tone Belt, $3.50. Tooled design with horseshoe buckle, $2. Wallet, $5. Other Belts from $2.

HICKOK
Quality Style Leadership

BELTS • BRACES • JEWELRY • WALLETS • GARTERS

Hickok Co. 1947.

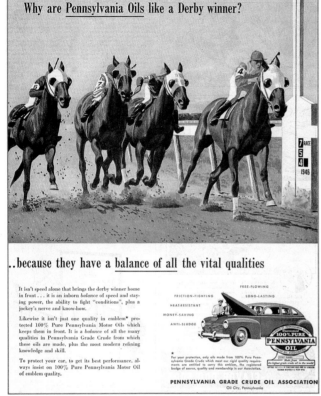

Pennsylvania Grade Crude Oil Assoc. 1946.

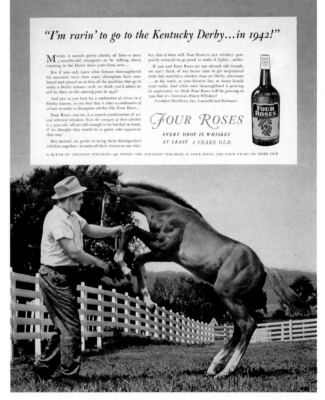

Frankfort Distilleries. 1940.

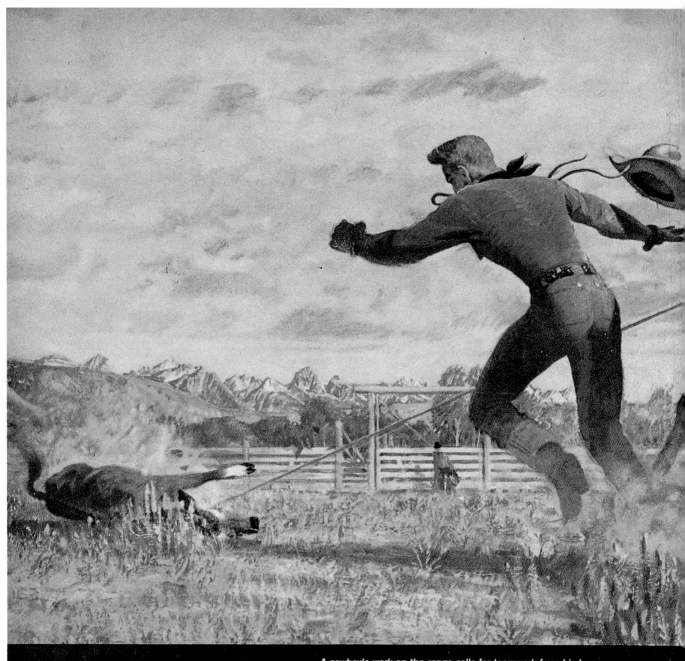

brake power...

A cowboy's work on the range calls for teamwork from his horse. Here "stopping" teamwork is illustrated . . . the same swift, sure stopping power that's yours in your Chrysler. The revolutionary Safe-Guard hydraulic brakes are an advance in safety which ranks with Chrysler's introduction of the <u>first</u> hydraulic brakes 24 years ago. Twin hydraulic cylinders on front wheels are balanced by single units in the rear in a lock-proof system that both creates and controls its own split-second brake power! Gives you more braking power with 30% less foot pressure! Makes it safer to enjoy your beautiful Chrysler.

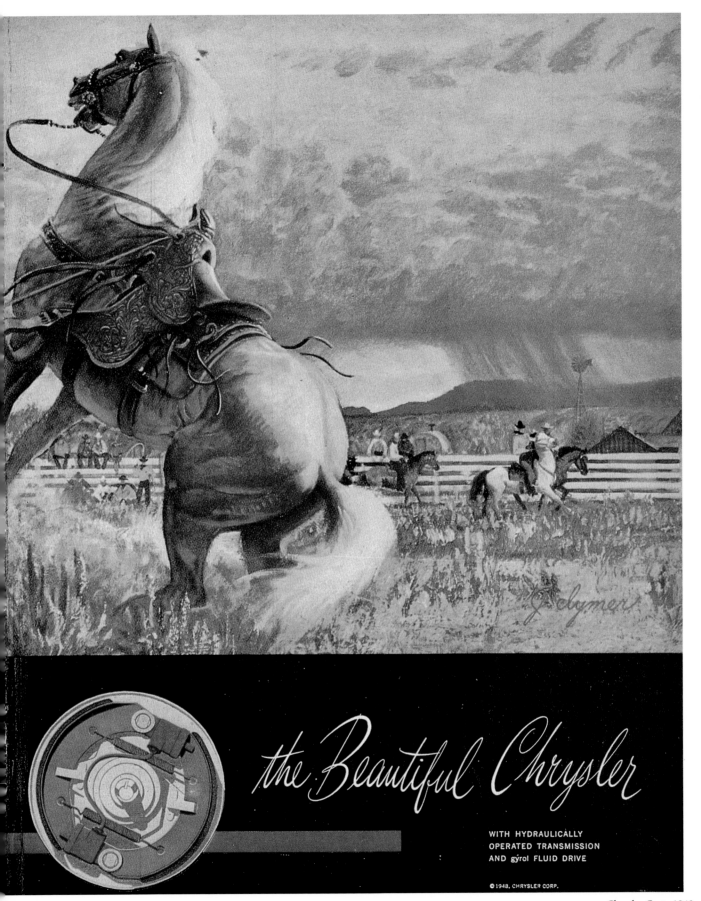

Chrysler Corp. 1948.

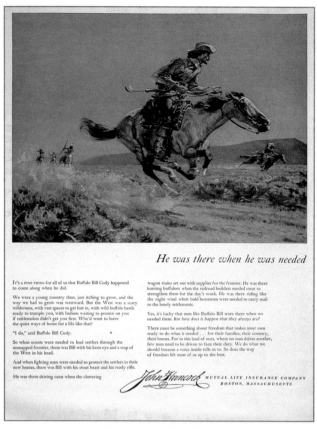

John Hancock Mutual Life Insurance Co. 1951.

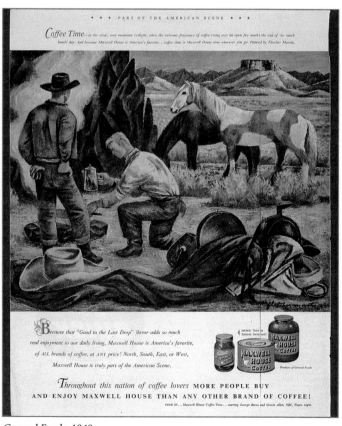

General Foods. 1948.

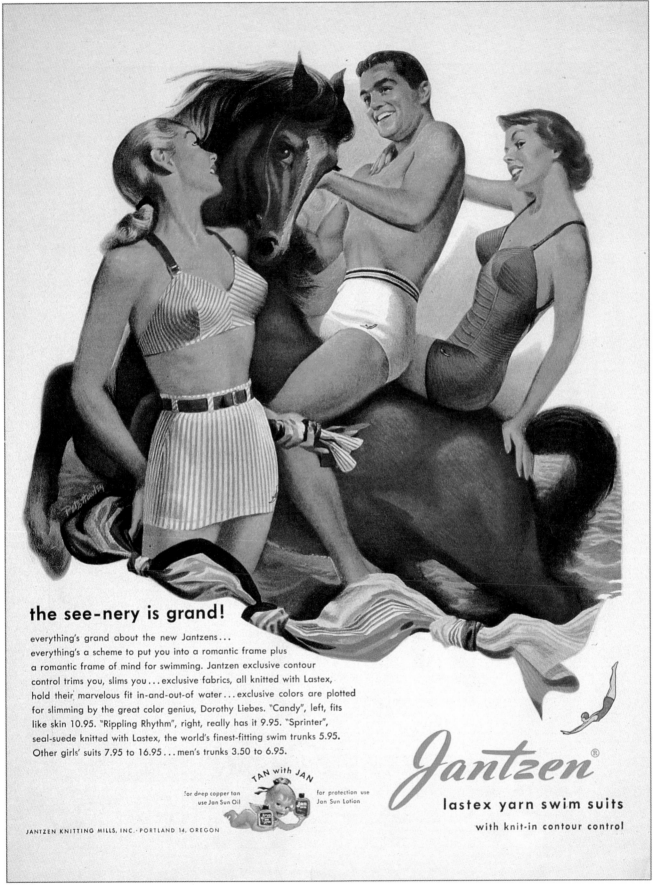

the see-nery is grand!

everything's grand about the new Jantzens...
everything's a scheme to put you into a romantic frame plus
a romantic frame of mind for swimming. Jantzen exclusive contour
control trims you, slims you...exclusive fabrics, all knitted with Lastex,
hold their marvelous fit in-and-out-of water...exclusive colors are plotted
for slimming by the great color genius, Dorothy Liebes. "Candy", left, fits
like skin 10.95. "Rippling Rhythm", right, really has it 9.95. "Sprinter",
seal-suede knitted with Lastex, the world's finest-fitting swim trunks 5.95.
Other girls' suits 7.95 to 16.95...men's trunks 3.50 to 6.95.

TAN with JAN

for deep copper tan
use Jan Sun Oil

for protection use
Jan Sun Lotion

JANTZEN KNITTING MILLS, INC.· PORTLAND 14, OREGON

Jantzen®

lastex yarn swim suits

with knit-in contour control

Jantzen, Inc. 1948.

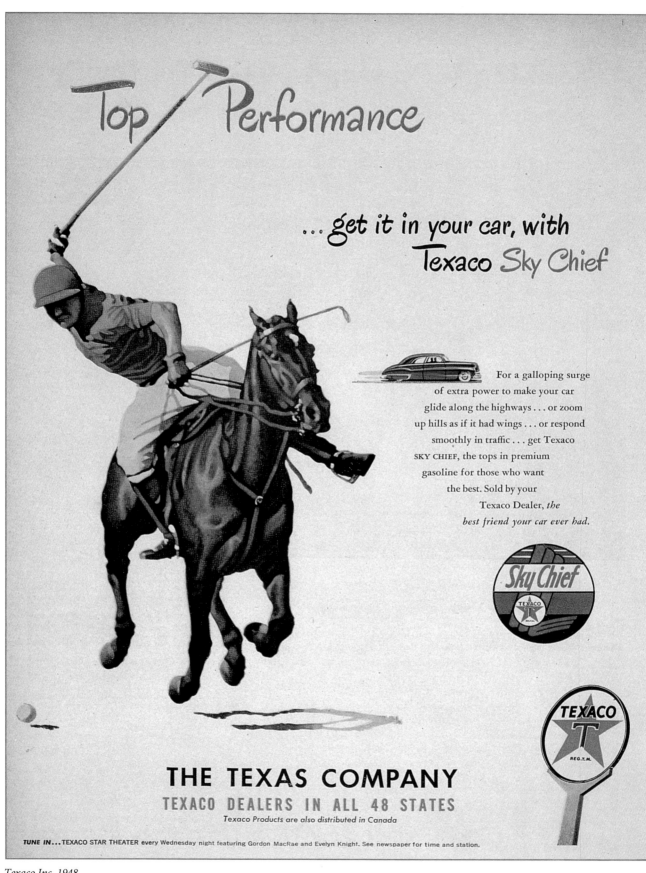

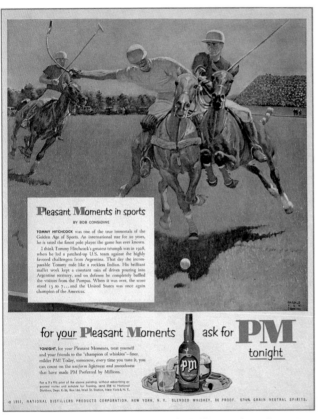

National Distillers Products Corp. 1951.

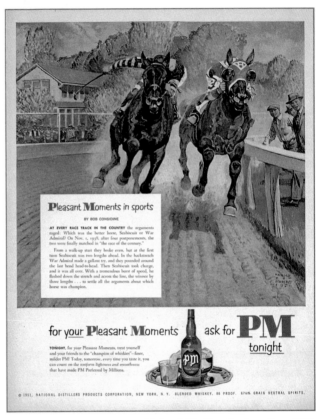

National Distillers Products Corp. 1951.

Make way for the Champion
Time, Patience and Skill put Hunter "First Over the Bars"

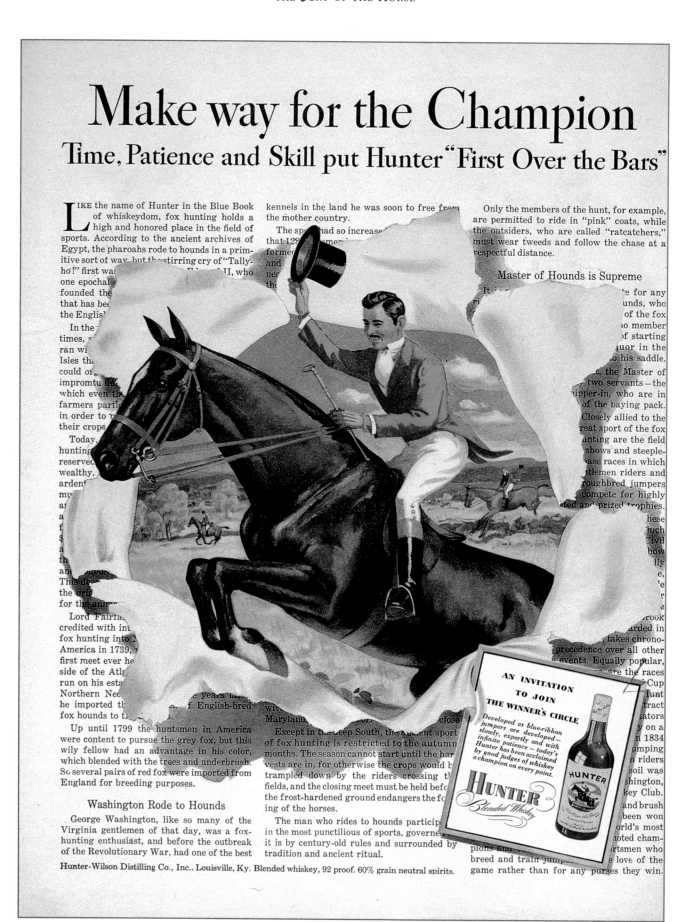

LIKE the name of Hunter in the Blue Book of whiskeydom, fox hunting holds a high and honored place in the field of sports. According to the ancient archives of Egypt, the pharoahs rode to hounds in a primitive sort of way, but the stirring cry of "Tally-ho!" first was ﬁ Ed II, who one epochal founded the that has bee the Englis

In the times, s ran wi Isles th could or impromtu which even the farmers partic in order to their crops

Today, hunting reserved wealthy, ardent mu a f s a th an This do the grip for the ani

Lord Fairfa credited with int fox hunting into America in 1739, first meet ever he side of the Atl run on his esta Northern Ned he imported th f English-bred fox hounds to t

Up until 1799 the huntsmen in America were content to pursue the grey fox, but this wily fellow had an advantage in his color, which blended with the trees and underbrush. So several pairs of red fox were imported from England for breeding purposes.

Washington Rode to Hounds

George Washington, like so many of the Virginia gentlemen of that day, was a fox-hunting enthusiast, and before the outbreak of the Revolutionary War, had one of the best

kennels in the land he was soon to free from the mother country.

The sp had so increase that 128 mer forme and ne th

wit Maryland close

Except in the deep South, the ancient sport of fox hunting is restricted to the autumn months. The season cannot start until the har vests are in, for otherwise the crops would b trampled down by the riders crossing th fields, and the closing meet must be held befo the frost-hardened ground endangers the fo ing of the horses.

The man who rides to hounds particip in the most punctilious of sports, governe it is by century-old rules and surrounded by tradition and ancient ritual.

Only the members of the hunt, for example, are permitted to ride in "pink" coats, while the outsiders, who are called "ratcatchers," must wear tweeds and follow the chase at a respectful distance.

Master of Hounds is Supreme

It i e for any ri unds, who of the fox o member of starting uor in the o his saddle. , the Master of two servants—the ipper-in, who are in of the baying pack. Closely allied to the reat sport of the fox nting are the field shows and steeple ase races in which tlemen riders and oughbred jumpers compete for highly ted and prized trophies. hese uch ivil how lly e, e r e rook arded in takes chrono- precedence over all other events. Equally popular, are the races Cup unt tract ators y on a n 1834 umping n riders soil was shington, key Club. and brush been won orld's most oted cham- rtsmen who e love of the game rather than for any purses they win.

Hunter-Wilson Distilling Co., Inc., Louisville, Ky. Blended whiskey, 92 proof. 60% grain neutral spirits.

Hunter-Wilson Distilling Co. 1948.

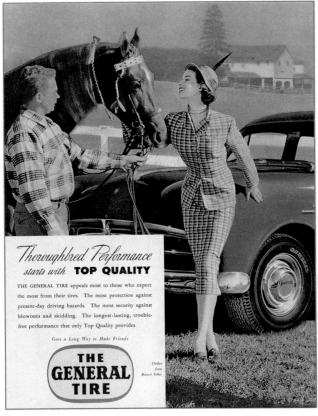

General Tire & Rubber Co. 1951.

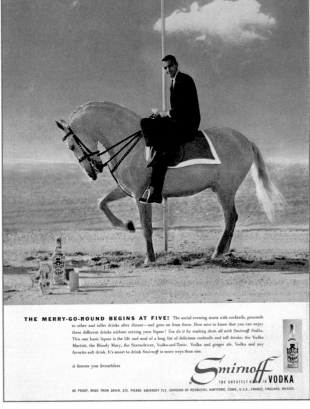

Heublein. 1955.

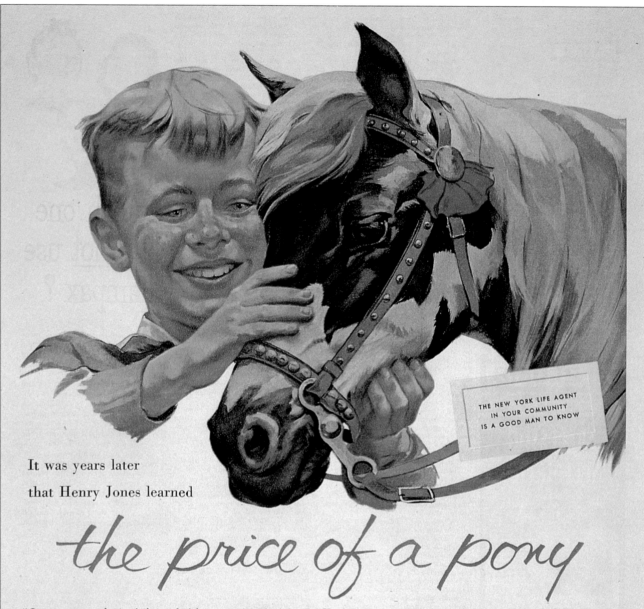

It was years later

that Henry Jones learned

the price of a pony

THE NEW YORK LIFE AGENT
IN YOUR COMMUNITY
IS A GOOD MAN TO KNOW

"ONE GOOD THING about *us* is that we don't have to worry about keeping up with the Joneses. We *are* the Joneses!"

That was one of Oscar Jones' favorite little jokes, and my Dad said he'd heard Oscar tell it a dozen times or more. But Dad also said it didn't keep Oscar Jones from doing his best to keep up with the Smiths, the Browns and a lot of other people in town.

For instance, when one of Oscar Jones' friends bought a big house down on Church Street, it wasn't long before Oscar bought an even bigger one. When another traded in his old car for a big, low-slung foreign car, Oscar Jones went right out and did the same. And when his son Henry left for the university in 1936, nothing would do for Oscar but to send his boy off in style in a shiny new roadster of his own. I went along with Henry, and was convinced—as I'm sure everyone else in town was—that Oscar Jones was a pretty rich man.

It was during our junior year that Henry got

word that his father died. He went home for a week or so to look after things—and never came back.

As I learned afterwards, all Oscar Jones left his family was a big house they couldn't keep up, a powerful car that didn't bring much at the used car lot, and a good many miscellaneous debts that Henry and his mother were hard-pressed to pay.

I lost track of Henry Jones for quite a few years after that, so I was a little surprised to find him waiting for me when I got to my office one morning last week. After a few minutes of general conversation he looked around and said, "I was in this office once before. That was back in the days when your father was an agent for New York Life, as you are now. I was only a kid then, but I still remember it. When we started out that morning, Dad had some money with him to pay the first premium on a policy your father had sold him.

"Well, on the way down we passed a place where they had a pony for sale. I wanted that pony more than anything—and that's where the money went.

Dad wouldn't take the policy that day in spite of everything your father said.

"It wasn't until I had to leave the university that I understood why your Dad had urged mine so strongly to change his mind about the policy. Then I realized how much that pony of mine had actually cost. I decided then that if I ever got married and had a family, I wouldn't make the same mistake."

Henry and I started working out his life insurance program then and there. A couple of days later he stopped in again and handed me a check for the first premium. "I didn't see any ponies this morning," he said.

I laughed and thanked him. He grinned and said, "Don't thank me—thank your father. He made this sale for you over twenty years ago."

NEW YORK LIFE INSURANCE COMPANY
51 Madison Avenue, New York 10, N. Y.

Naturally, names used in this story are fictitious.

New York Life Insurance Company. 1952.

Next to Nature_it's Ansco *Natural* Color!

Imagine! Stills or movies in gorgeous <u>natural</u> color...at a price you can afford!

Soft flesh tones, natural foliage, pastel-blue skies . . . that's Ansco *Natural* Color. Every transparency, every print, every foot of movie film, gives you sparkling pictures that spring to life with nature's gorgeous panorama of color. Be sure to load your camera (f6.3 lens or faster) today, with the one and only Ansco *Natural* Color Film! At dealers everywhere! Available in 120 and 620 rolls, 35mm magazines, sheets, and 50 and 100 foot rolls for 16mm movie cameras.

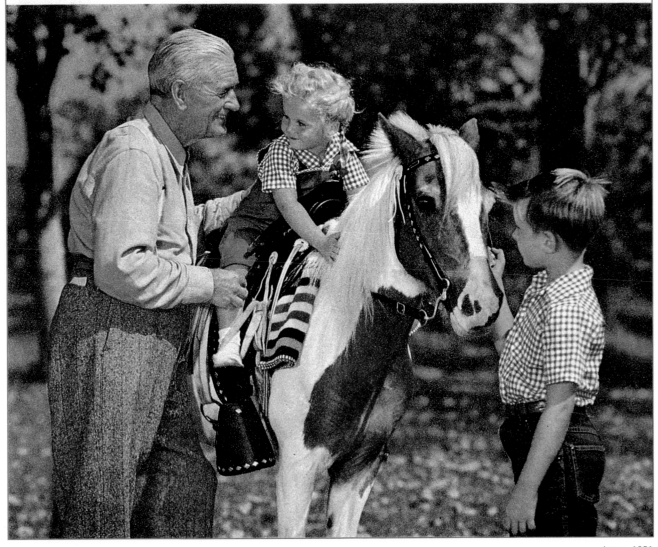

Ansco. 1951.

POSTCARDS

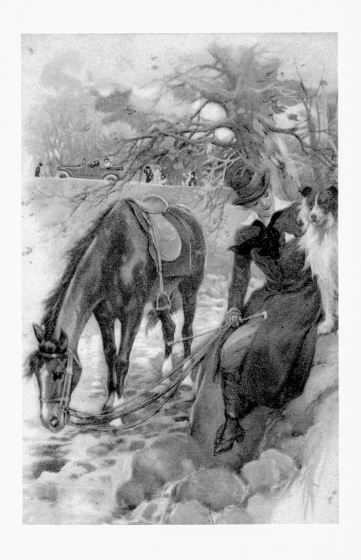

U.S.A. c.1910.

"When archaeologists of the thirtieth century begin to excavate...ruins..., they will focus their attention on the picture postcard as the best means of penetrating the spirit of the...era. They will collect and collate thousands of these cards and they will reconstruct our epoque from the strange hieroglyphics and images they reveal, spared by the passage of time."

James Douglas
English journalist, 1907

England. H. Eliot. c.1900.

U.S.A. 1908.

𝒫icture postcards originated in Europe in the early 1870s. Production increased in the 1890s with the introduction of new printing techniques and the extension of licenses to private industry to publish postcards. Collotype printing became available on an industrial scale, which led to a proliferation of photographic postcards and color lithography.

Social and cultural factors encouraged the growth of postcards well into the twentieth century. The brevity of the verbal message and the presence of the illustration to augment the written word, by amplifying its meaning or charging it with allusions, were among the reasons for the extraordinary popularity of postcards.

The appearance of the postcard brought about some interesting changes in Victorian and Edwardian letter-writing habits. A letter's contents were concealed inside an envelope, which was considered an improper means of communication for young lovers. A postcard, on the other hand, made it possible to inspect what was written and was therefore more acceptable.

"Like many great inventions," observed the English journalist James Douglas in 1907, "the postcard has brought a silent revolution in our habits. It has freed us unexpectedly from the fatigue of writing letters. There is no space for courtesy."

The postcard became a means of picturesque documentation at a low price, and it was coveted by millions of collectors worldwide. Postcards served as a substitute for those who could not afford first-hand experiences of the places and the subjects represented in them. At the turn of the century, postcard stalls or kiosks were a common sight in public gardens and exhibition parks in European cities, as were postcard salesmen passing along trains, or from table to table in cafes and restaurants.

Before 1907 writing was generally not permitted on the address and stamp side of the postcard (the reverse side of the graphic). Senders of cards had to write their message over the image on the front (graphic) side. In 1907 it became permissible for the writer to use the newly created divided back side for the message, keeping the graphic image clean for the recipient and for posterity.

The golden age of the picture postcard ran from 1898 to the end of the First World War in 1918. During those twenty years many artists and photographers in Europe, the United States and elsewhere developed graphics for postcard publishers. The postcard brought both art and the photographic experience within the range of the general public.

U.S.A. c.1910.

Women assumed a central role in postcard iconography, and they were popularized by postcard artists in many different situations. Artists often escaped into fantasy with their symbolic and sublime elevations of women into stylized, idealized beings. Significantly, the woman was the principal subject in most illustrators' work, even when there was a man at her side.

Children also figured prominently in picture postcards throughout the world. In most cases, the image of childhood, with its uninhibited joy in living, its implicit message of hope for the future, and its innocence and openness, was bound up with such messages or greetings as: "Merry Christmas," "Happy Easter" and "Happy New Year."

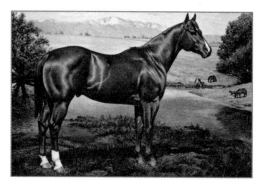

U.S.A. c.1960.

Sport in general, including riding, has always been a major theme of postcards. Participatory sport emerged as a new phenomenon around the turn of the century, its mass appeal becoming synonymous with modernism. Sport was a heroic activity, and horses became an intensely popular postcard subject worldwide.

The postcard was also a means of promoting or reflecting trends in current fashion. As such, postcards are valuable records of equestrian fashions for both men and women throughout the historic period covered in this volume.

With the availability of photographic postcards, equestrian photos became a popular subject for many postcard publishers, bringing the view closer to the beauty of the horse. Many riding clubs, recognizing the benefits of worldwide attention and publicity, published their own picture postcards to promote their tourist facilities and to further the glamorous appeal of the sport.

Postcards became important documents for revealing the international spread of horsemanship as a popular pursuit. Particularly after World War I, without the availability of this medium,

much of the populace would have had no resource for discovering the excitement of horses and riding.

While collections of postcards in public museums do exist today, the collection of cards is primarily the domain of individuals who buy and trade cards, much as their grandparents did generations ago. Now many collectors also do so to preserve and record the history of times past.

When viewed closely, each postcard in this collection has a story to tell. The scenery, characters and action scenes are static, but they can be brought to life vividly with a bit of imagination and with close attention to the depictions of clothing styles, tack and saddlery, grooming and locations. Through close observation these images can greatly enhance our ability to imagine the experience of horsemanship as it existed around the turn of the century.

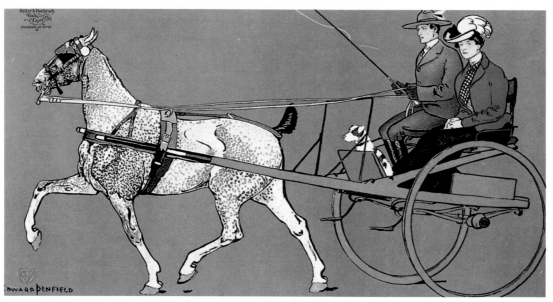

U.S.A. Edward Penfield. 1900.

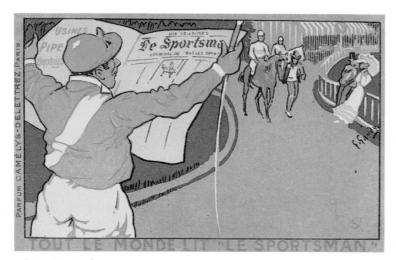

Belgium. G. Gaudy. c.1900.

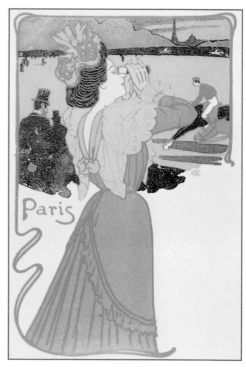

Germany. H. Christiansen. 1900.

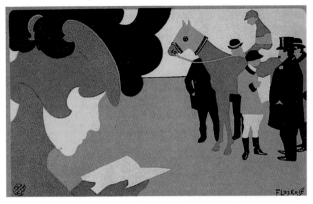

Poland. F. Laskoff. c.1900.

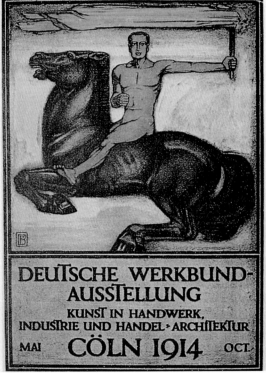

Germany. P. Behrens. 1914.

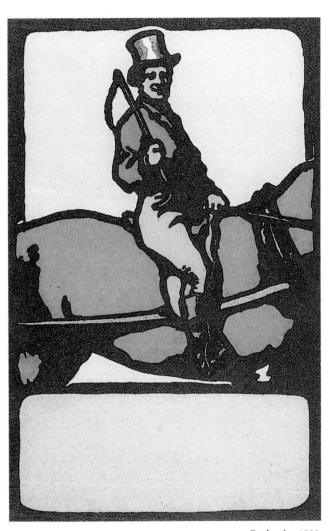

England. c.1900.

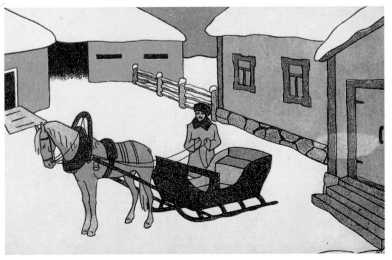

Finland. A. Paischeff. c.1917.

Germany. 1898.

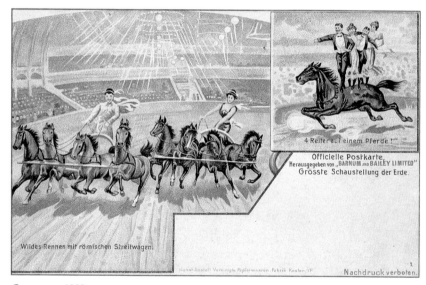

Germany. c.1900.

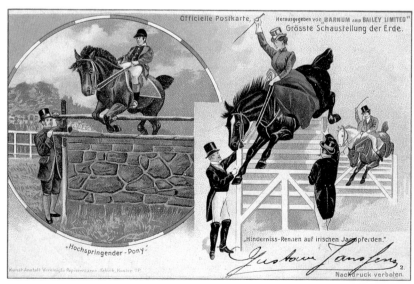

Germany. c.1900.

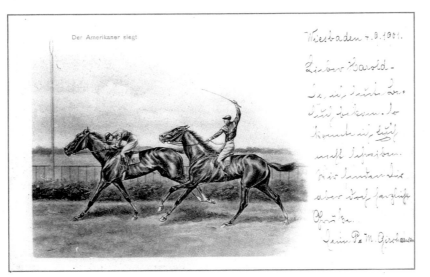

Germany. 1901.

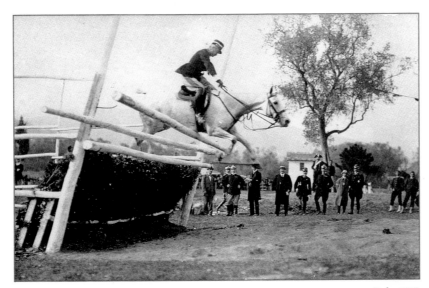

Italy. 1918.

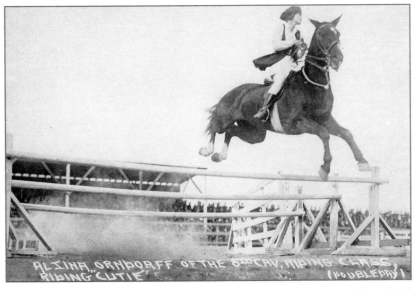

U.S.A. c.1915.

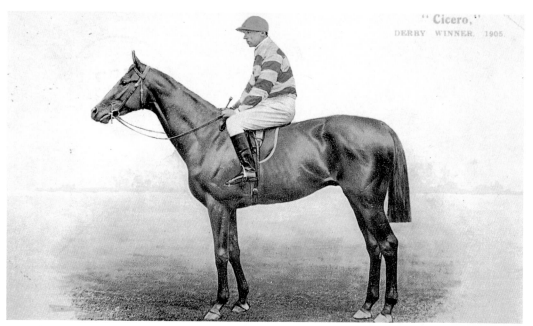

England. 1910.

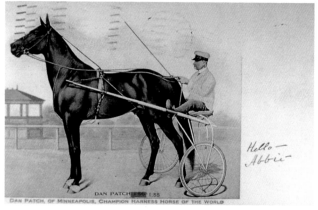

U.S.A. c.1908.

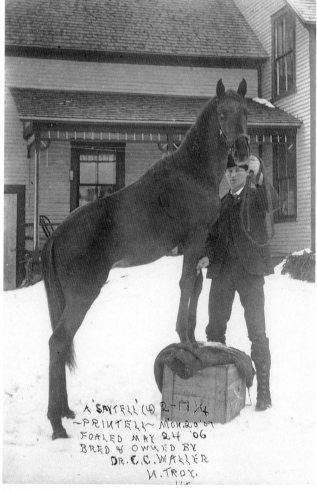

U.S.A. 1908.

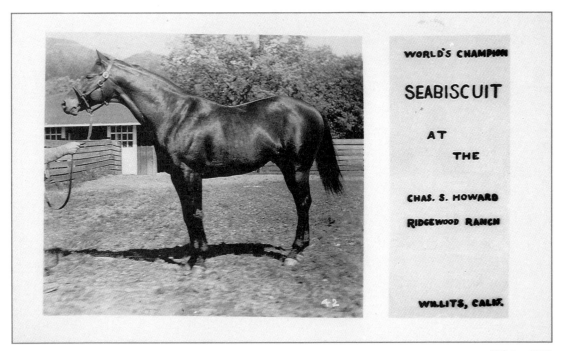

U.S.A. c.1938.

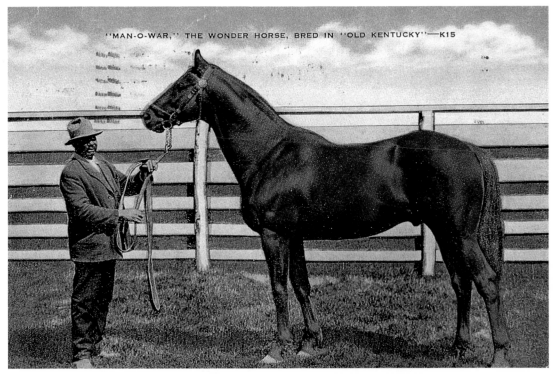

U.S.A. 1942.

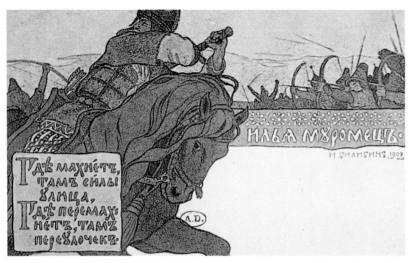

Soviet Union. I. Bilbin. 1902.

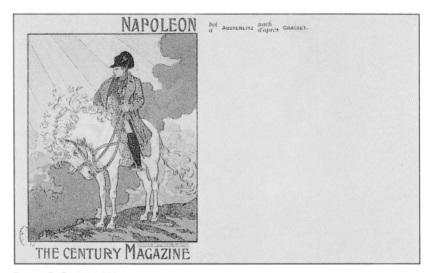

France. E. Crasset. 1898.

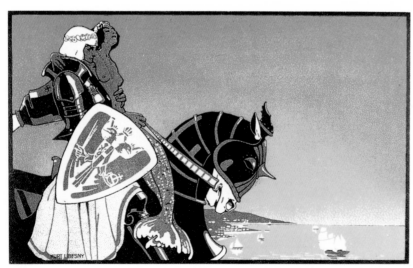

Austria. K. Libesny. 1913.

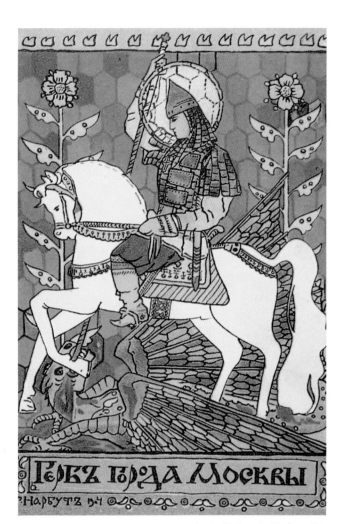

Soviet Union. G. Narbut. 1904

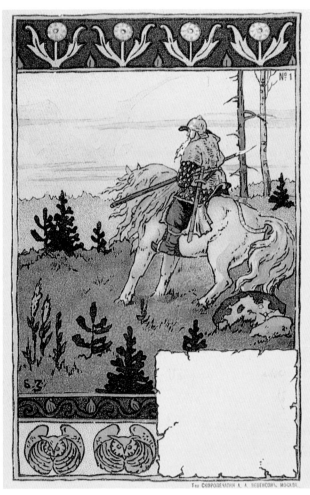

Soviet Union. c.1900.

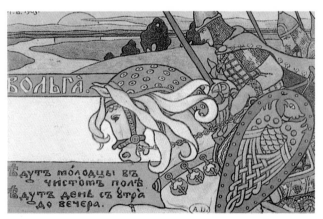

Soviet Union. I. Bilbin. 1903.

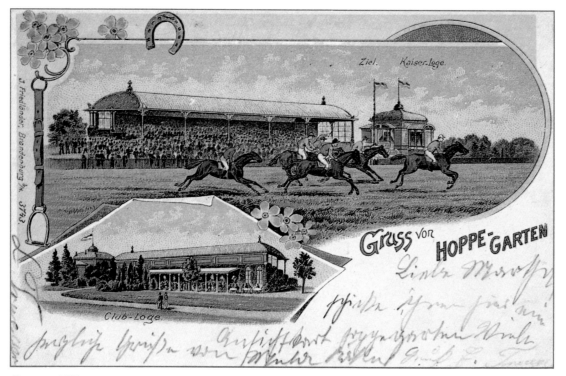

Germany. 1903.

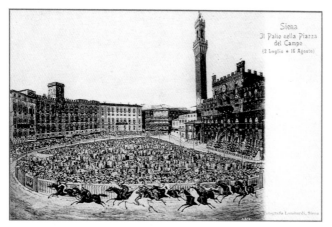

Italy. c.1905.

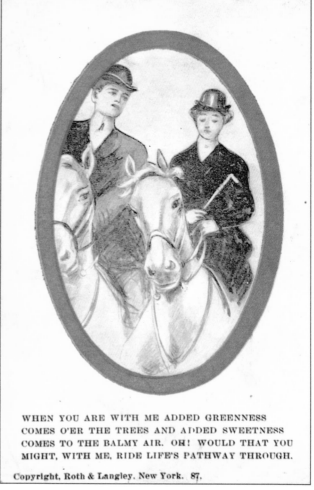

WHEN YOU ARE WITH ME ADDED GREENNESS
COMES O'ER THE TREES AND ADDED SWEETNESS
COMES TO THE BALMY AIR. OH! WOULD THAT YOU
MIGHT, WITH ME, RIDE LIFE'S PATHWAY THROUGH.

Copyright, Roth & Langley, New York. 87.

U.S.A. 1910.

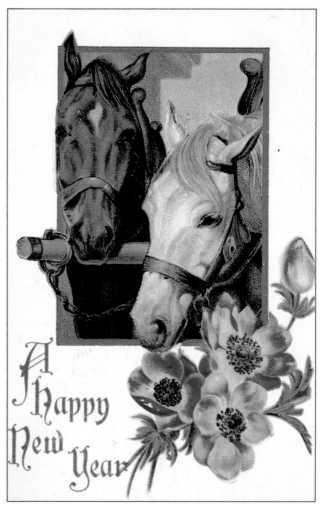

England. 1908.

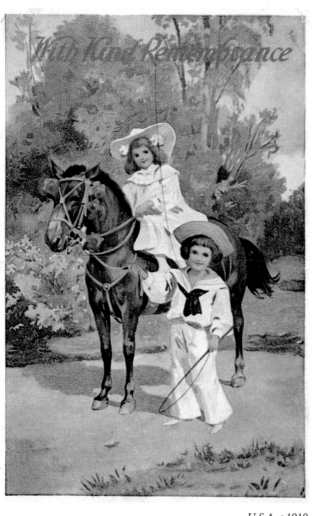

U.S.A. c.1910.

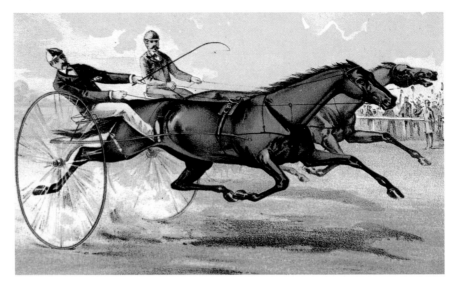

England. c.1905.

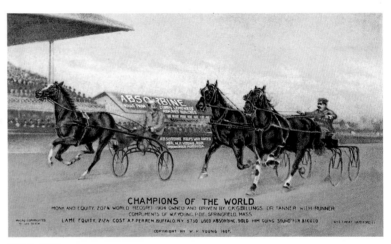

CHAMPIONS OF THE WORLD

U.S.A. 1907.

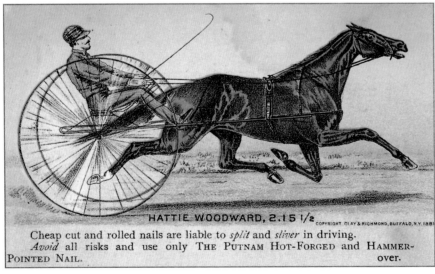

HATTIE WOODWARD, 2.15 1/2
COPYRIGHT, CLAY & RICHMOND, BUFFALO, N.Y. 1881

Cheap cut and rolled nails are liable to *split* and *sliver* in driving.
Avoid all risks and use only THE PUTNAM HOT-FORGED and HAMMER-
POINTED NAIL. over.

U.S.A. 1881.

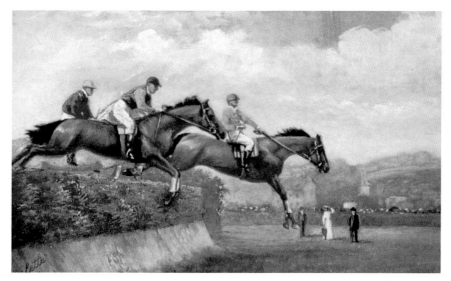

England. c.1910.

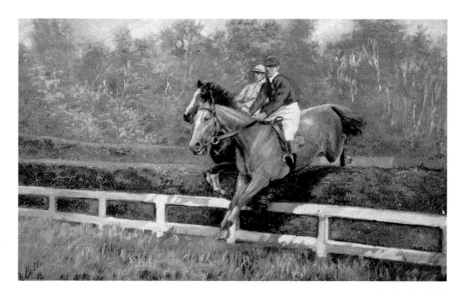

England. c.1910.

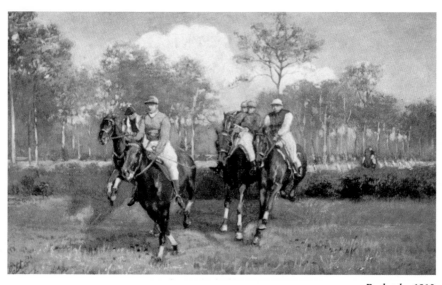

England. c.1910.

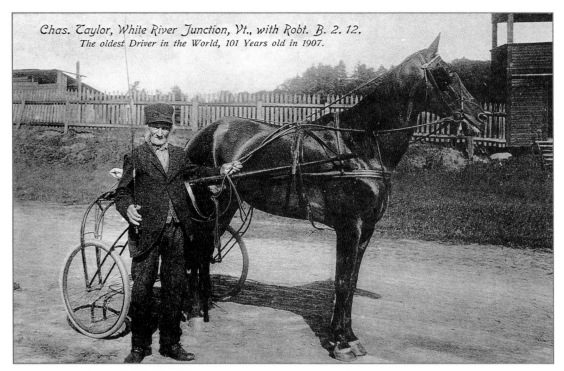

Chas. Taylor, White River Junction, Vt., with Robt. B. 2. 12.
The oldest Driver in the World, 101 Years old in 1907.

U.S.A. 1907.

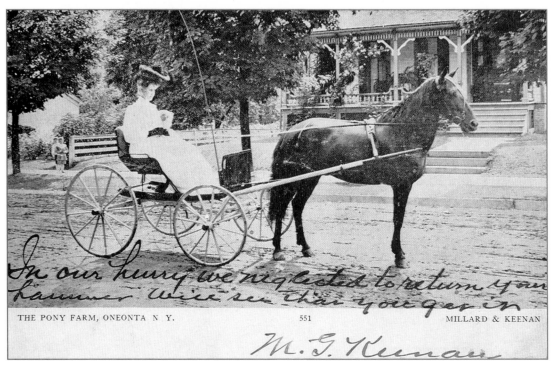

THE PONY FARM, ONEONTA N.Y. 551 MILLARD & KEENAN

U.S.A. 1908.

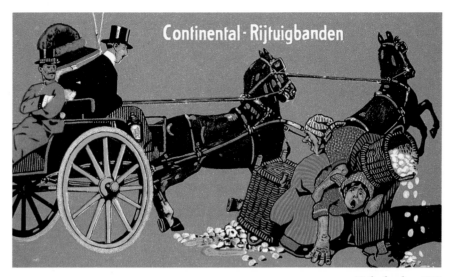

Netherlands. c.1910.

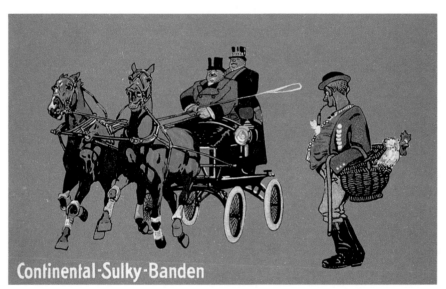

Netherlands. c.1910.

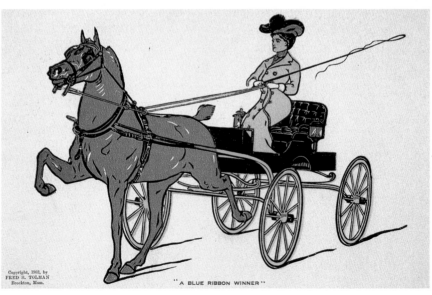

U.S.A. 1903.

Austria. c.1910.

Germany. 1910.

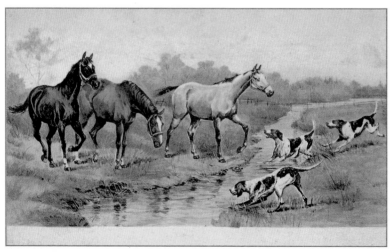

Austria. c.1910.

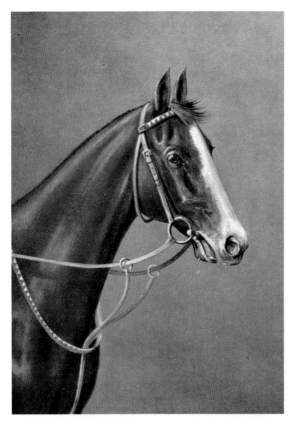

England. c.1920.

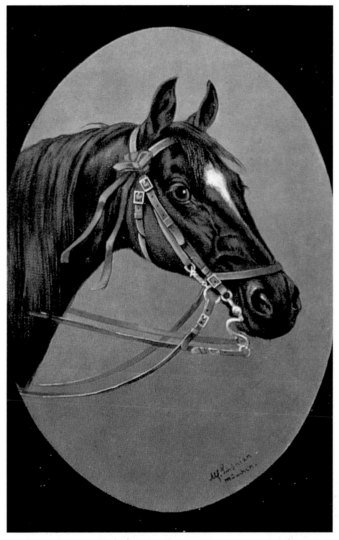

U.S.A. c.1920.

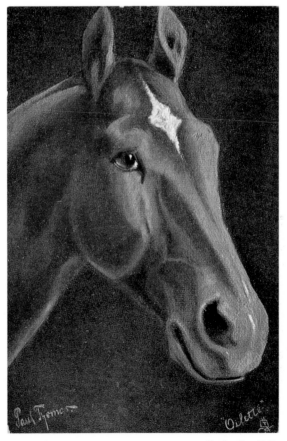

England. c.1910.

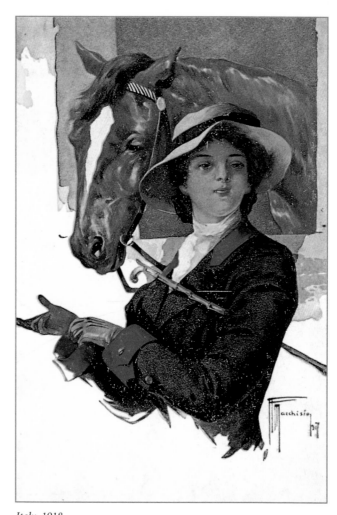

Italy. 1918.

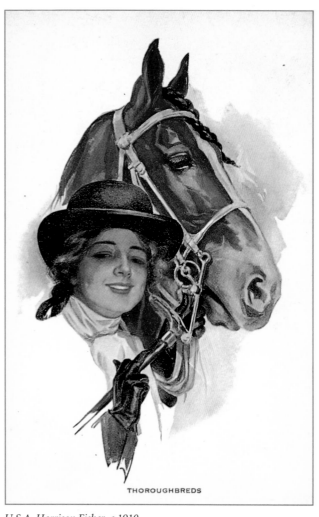

THOROUGHBREDS

U.S.A. Harrison Fisher. c.1910.

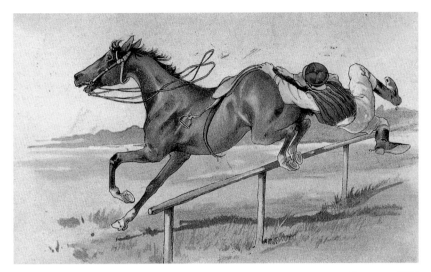

Germany. 1908.

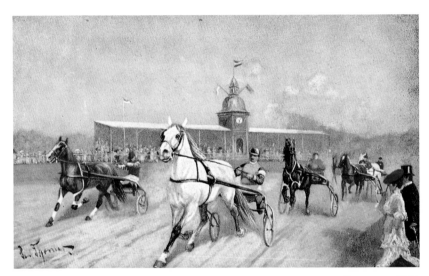

Germany. c.1910.

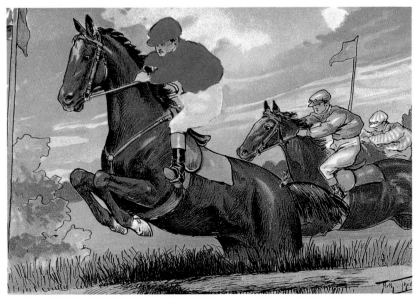

U.S.A. Arthur Thiele. c.1910.

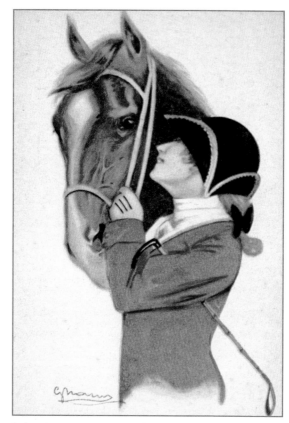

Italy. 1917.

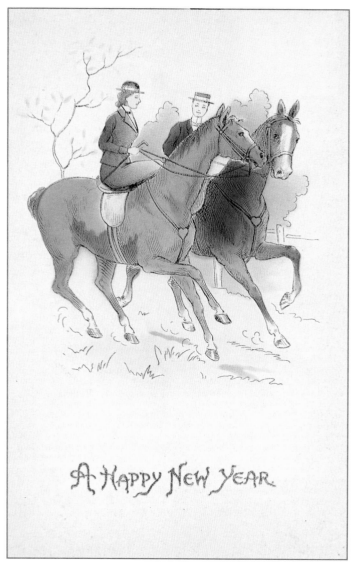

A HAPPY NEW YEAR.

U.S.A. 1907.

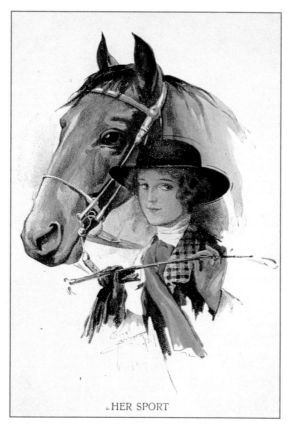

HER SPORT

England. Court Barber. c.1915.

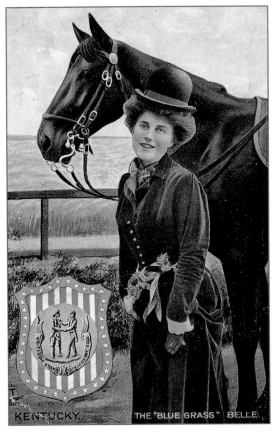

U.S.A. c.1910.

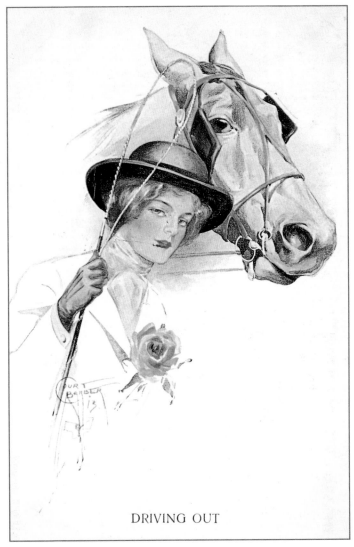

DRIVING OUT

England. Court Barber. 1915.

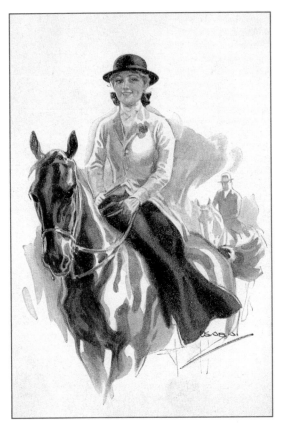

Luis Usabal. c.1920.

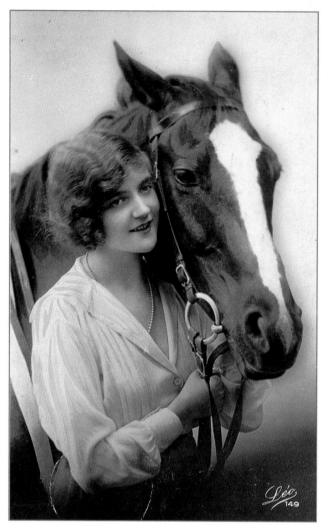

Belgium. 1920.

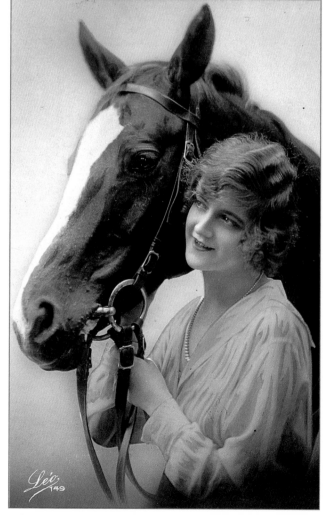

Belgium. 1920.

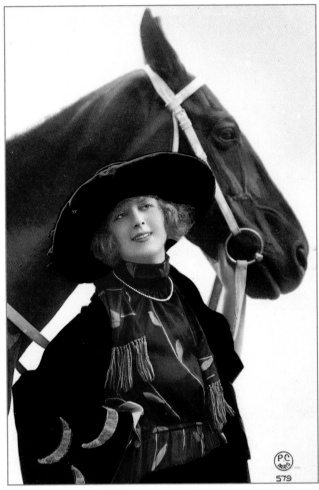

Belgium. 1920.

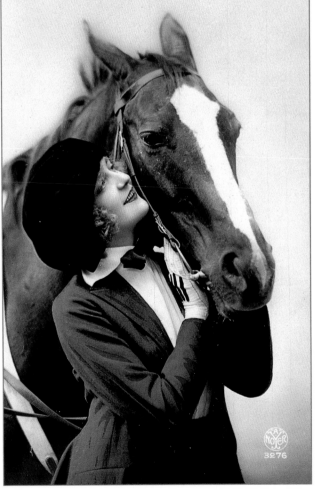

Belgium. 1920.

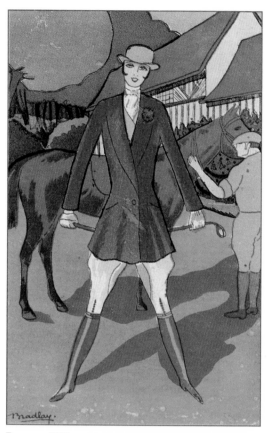

Europe. c.1925.

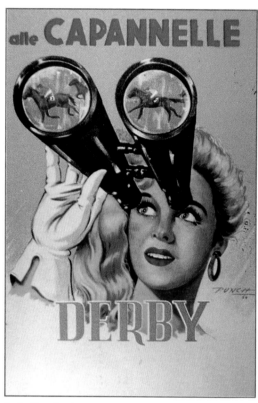

Italy. Punch. 1954.

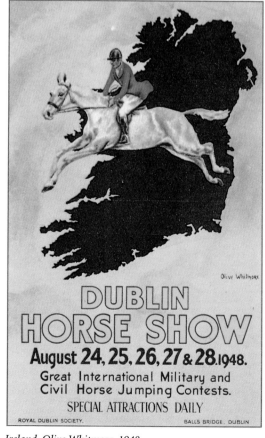

Ireland. Olive Whitmore. 1948.

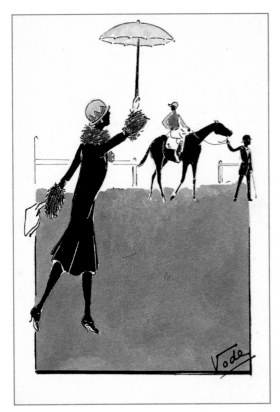

Europe. c.1925.

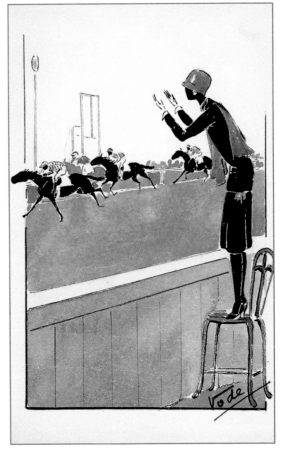

Europe. c.1925.

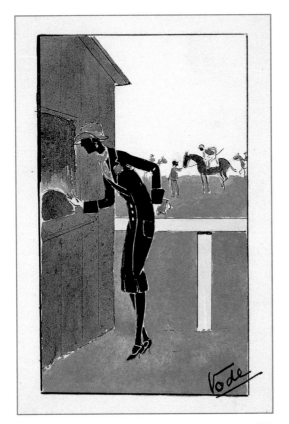

Europe. c.1925.

ACKNOWLEDGEMENTS

Nearly all of the artwork and graphic materials reproduced in this book are from the personal collection of the author. Ownership of and permission to use these and other materials reproduced herein are acknowledged below. While the publisher makes every effort possible to publish full and correct information for every work, in some cases errors may occur. The publisher regrets any such errors but must disclaim any liability in this regard.

Ansco Photo-Optical Products Corporation.
Arrow Shirts. Bidermann Industries.
Child Life. Copyright ©1945 by Child Life, Inc. Used by permission of Children's Better Health Institute, Benj. Franklin Literary & Medical Society, Inc., Indianapolis, IN.
Chrysler Corporation.
Coca-Cola. Coca-Cola is a registered trademark of The Coca-Cola Company and is used with permission.
Country Gentleman. Copyright © Curtis Publishing Co. Reprinted by permission.
Dow Chemicals. Used with permission of the Dow Chemical Company.
Fortune Magazine. © 1933 Time Inc. All rights reserved.
General Motors. Reprinted with permission of General Motors Corporation.
General Tire.
John Hancock Life Insurance. Reprint permission granted by John Hancock Mutual Life Insurance Company, Boston, MA 02117.
Jantzen. Reprinted by permission of Jantzen Inc., Portland, OR.
Kodak. Reprinted courtesy of Eastman Kodak Company.
Kotex. KOTEX is a trademark of Kimberly-Clark Corporation. Reprinted with permission.
Ladies' Home Journal. © Copyrights 1898, 1922, 1923, Meridith Corporation. All rights reserved. Reprinted from *Ladies' Home Journal* magazine.
PM Whiskey. Jim Beam Brands Co.
Saturday Evening Post. Copyright © Curtis Publishing Co. Reprinted by permission.
Smirnoff Vodka. Heublein Inc.
Southern Pacific. Southern Pacific Transportation Company.
Squibbs Dental Cream. Reprinted by permission of E.R. Squibb & Sons, Inc., copyright owner.
Texaco. Texaco Inc.
Vanity Fair. Courtesy *Vanity Fair.* Copyright ©1934 (renewed 1962) by The Conde Nast Publications Inc.
Vogue. Copyrights 1931, 1932 (renewed 1959, 1960) by The Conde Nast Publications Inc.

INDEX